ART IN MOTION

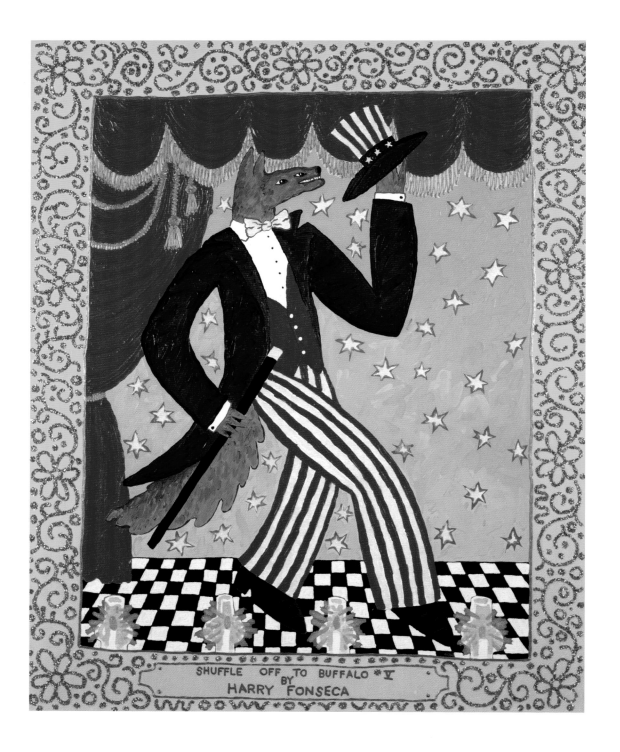

SHUFFLE OFF TO BUFFALO #V
BY
HARRY FONSECA

ART IN MOTION

NATIVE AMERICAN EXPLORATIONS
OF TIME, PLACE, AND THOUGHT

Edited by

JOHN P. LUKAVIC
and
LAURA CARUSO

Text and compilation of images © 2016 Denver Art Museum

Images © Denver Art Museum or as indicated in the captions

Denver Art Museum
100 W. 14th Ave. Pkwy
Denver, CO 80204
denverartmuseum.org

ISBN 978-0914738-63-3

Library of Congress control number 2016934870

Copyedited by Laura Caruso, Denver Art Museum

Designed by Mary Junda, Junda Graphics, Denver

Printed in Hong Kong

Distributed by University of Oklahoma Press
2800 Venture Drive
Norman, OK 73069-8216
800.627.7377
oupress.com

Cover: Dan Namingha, *Hopi Eagle Dancer*, 1995 (fig. 3)

Frontispiece: Harry Fonseca (Maidu, 1946–2006),
Shuffle Off to Buffalo #V, 1983. Acrylic and mixed media on
canvas, 60 x 48 in. (152.40 x 121.92 cm). Denver Art Museum:
William Sr. and Dorothy Harmsen Collection, by exchange,
2005.63. © Estate of Harry Fonseca

Back cover: Charlene Holy Bear, *The Shawl*, 2012 (fig. 66)

CONTENTS

FOREWORD

Since 1925, the Denver Art Museum has maintained its commitment to presenting American Indian arts through exhibitions, public programs, lectures, and symposia. Under the leadership of Nancy Blomberg, curator of native arts since 1993, the museum has hosted several symposia on American Indian arts, including *[Re]inventing the Wheel: Advancing the Dialogue on Contemporary American Indian Art* (2006) and *Action and Agency: Advancing the Dialogue on Native Performance Art* (2008), both of which were also compiled into publications.

The symposium that led to this publication, *Art in Motion: Native American Explorations of Time, Place, and Space* (2012), was organized by associate curator of native arts John P. Lukavic. It has been followed by two more symposia: *The Art of Remembrance: 150 Years Since Sand Creek* (2014) and *In Dialogue: Fritz Scholder and the Art World* (2016).

All of these symposia are part of an ongoing initiative by the Denver Art Museum's Native Arts Department to advance and promote the understanding of American Indian arts. In addition to symposia, this initiative is advanced through groundbreaking and award-winning exhibitions such as *Artist's Eye, Artist's Hand* (2011); *Red, White & Bold: Masterworks of Navajo Design, 1840–1870* (2013); *Sovereign: Independent Voices* (2013); *Revolt 1680/2180: Virgil Ortiz* (2015); and *Super Indian: Fritz Scholder, 1967–1980* (2015). Furthermore, since 2012 the native arts staff, in collaboration with the museum's Department of Learning and Engagement,

has developed and run the Native Arts Artist in Residence program, which has hosted such leading artists as Gregg Deal, Jeffrey Gibson, Rose Simpson, Marie Watt, Will Wilson, Melanie Yazzie, and the artist collective Post Commodity, to name a few. Our initiative also includes an active acquisitions program with an emphasis on adding contemporary art by American Indian artists to the permanent collection. And, for twenty-seven years the museum has hosted an annual Friendship Powwow and American Indian Cultural Celebration each September.

This incredibly rich roster of programs is supported by generous individual donors and institutions. It is also made possible by the Friends of Native Arts: The Douglas Society, a support group for the Native Arts Department, which has been a staunch supporter of our goals and mission. We also recognize the citizens who support the Scientific and Cultural Facilities District for their ongoing support. On behalf of the Denver Art Museum, I extend my thanks to all the supporters, artists, scholars, and visitors who help to make each of these programs a success.

Christoph Heinrich
Frederick and Jan Mayer Director
Denver Art Museum

ACKNOWLEDGMENTS

In 2012, immediately after joining the staff at the Denver Art Museum, I was privileged to organize the symposium that led to this publication, *Art in Motion: Native American Explorations of Time, Place, and Space*. Inspired by the way the figurative dolls created by Standing Rock Lakota Sioux artist Charlene Holy Bear depicted motion, I began to think about other ways in which motion plays a role in the work of native artists. I invited scholars Kristin Dowell, Aldona Jonaitis, and Daniel Swan, along with artists Charlene Holy Bear, Leena Minifie, and Kent Monkman, to talk about how they applied and interpreted the concept of "art in motion" to Native American arts. Their responses were broader and more intriguing than I could have imagined. I thank them for their thought-provoking and insightful contributions to the symposium and their willingness to revisit the topic in print.

From the conception of the symposium that led to this publication to final edits, the staff of the Denver Art Museum has kept this project on track. Eric Berkemeyer, curatorial assistant in native arts, managed the image rights, secured photography, and obtained and verified credit lines and captions, with crucial assistance from Renée Miller. Staff photographers Jeff Wells and Christina Jackson provided images from works in the museum's collection and were quick to respond to new requests that inevitably popped up in the design phase of this publication. I also thank native arts intern Nicole Dial-Kay for her help researching artists and the broad theme of the symposium.

I extend a very special thank you to Laura Caruso, director of publications at the Denver Art Museum, who partnered with me to bring this publication to completion and whose incredible skill as an editor helped to shape this into a volume of which we are all proud. Thank you also to Mary Junda for designing this publication and to University of Oklahoma Press for distributing it to an audience beyond the walls of the museum. I extend my appreciation to Christoph Heinrich, Frederick and Jan Mayer Director of the Denver Art Museum, for his unwavering support of native arts and the programs we present, and to Nancy Blomberg, chief curator and curator of native arts, for putting her trust in me to continue the legacy and scholarship of native arts at the Denver Art Museum.

John P. Lukavic
Associate Curator of Native Arts

INTRODUCTION

The Concept of Motion Applied to Native American Art

John P. Lukavic

In the summer of 2012, the Denver Art Museum hosted a symposium titled *Art in Motion: Native American Explorations of Time, Place, and Thought*, which brought together artists Charlene Holy Bear, Leena Minifie, and Kent Monkman with scholars Kristin Dowell, Aldona Jonaitis, and Daniel Swan to discuss American Indian art using the idea of motion as a unifying theme. The symposium was largely inspired by the figurative dolls created by Holy Bear. When I first saw the dancer figure she calls *The Shawl* (see figure 66), which has since been acquired by the Eiteljorg Museum in Indianapolis, I was struck by the way it depicted motion, even though it does not move. That led me to think about other ways in which motion plays a role in the work of native artists.

Coincidentally, as I write this introduction in the winter of 2015 (publications following symposia are notorious for coming out several years after the event), the Denver Art Museum is developing an exhibition, *Why We Dance: American Indian Art in Motion*, that explores diverse media, community associations, and uses of dance in American Indian arts—including historical and contemporary ceremonial dance and powwow arts (fig. 1),

Pueblo paintings from the 1920s to mid-1950s that depict dances (fig. 2), contemporary paintings and mixed-media works that either suggest motion (fig. 3) or make tangible references to motion by incorporating, for example, materials actually used in powwow arts (fig. 4), and a large video-based installation piece by Alan Michelson that incorporates visual movement in a stationary artwork. The varying perspectives discussed in the 2012 symposium and the essays in this volume contributed to the conceptual planning for the 2016 exhibition by helping our team think broadly about dance and motion.

"Motion" turned out to be a wonderfully fruitful theme for a symposium, and the perspectives explored within these texts provide examples of ways in which scholars and artists can use overarching themes, such as motion, to investigate the materiality of arts and culture. It is an especially rich concept, stretching as it does across time and space and having broad metaphorical significance. The use of motion as an organizing theme to analyze native arts is not unique. The work of Yale professor Robert Farris Thompson on African and diaspora arts and dance are seminal in the field (see Thompson 1974 and 2011).

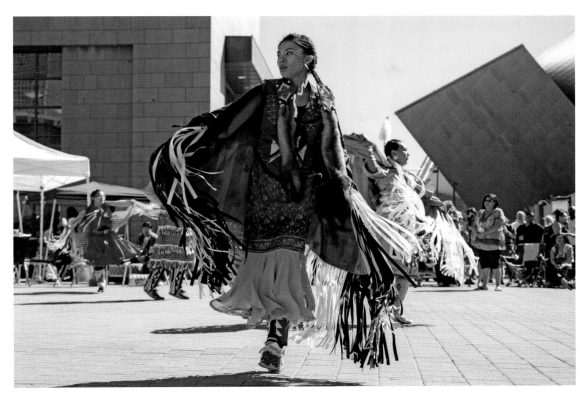

Fig. 1: Dancers at the 26th Annual Friendship Powwow at the Denver Art Museum, 2015

And, of course, it is a theme that scholars who study dance and time-based media grapple with, since motion is inherent in such works. Here, however, I wanted to see what the invited artists and scholars came up with using the theme of motion as a springboard, interpreting the concept as they thought applicable to North American native arts.

Discussions of dance, as found in the essays by Holy Bear, Jonaitis, and Minifie, necessarily deal with actual physical movement; in fact, Jonaitis specifically references particular movements and their relations to clans. Time-based art, as explored by Dowell and Minifie, deals with chronological movement. Physical or actual movement is often expressed in sculptural arts, as seen in Holy Bear's examples.

Many of our authors seized upon less literal meanings of the word "motion." Cultural change over time, as addressed by Monkman, Jonaitis, and Swan, proves to be another form of motion, albeit in a metaphorical way. Cultures change in many ways, but through the act of looking back, these changes can mark circular movement. When artists draw upon their own experiences or tribal history,

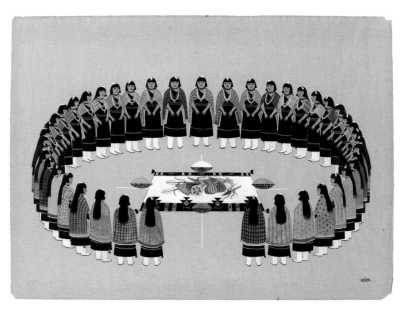

Fig. 2: Awa Tsireh (San Ildefonso, 1895–1955), *Harvest Dance*, 1930. Watercolor on paper, 15⅞ x 23½ in. (40.32 x 59.69 cm). Denver Art Museum: Gift of Anne Evans and Mary Kent Wallace, 1932.207.

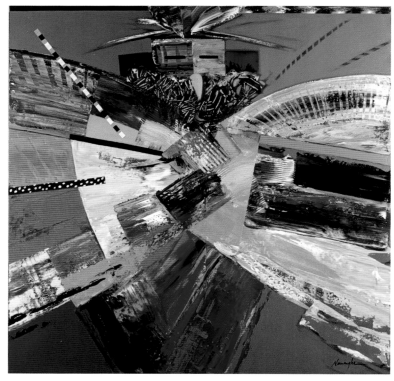

Fig. 3: Dan Namingha (Tewa/Hopi, born 1950), *Hopi Eagle Dancer*, 1995. Acrylic paint on canvas, 47¾ x 47¾ in. (121.29 x 121.29 cm). Denver Art Museum: Gift of Virginia Vogel Mattern, 2003.1296. © Dan Namingha

Fig. 4: Marie Watt (Seneca, born 1967), *Butterfly*, 2015. Reclaimed wool blankets, satin binding, thread, cotton twill tape, and tin jingles, 94 × 126 in. (238.76 × 320.04 cm). Denver Art Museum: Funds from Vicki & Kent Logan and Loren Lipson, M.D., with additional funds from Brian Tschumper, Nancy Benson, Jan & Mike Tansey, and JoAnn & Bob Balzer. © Marie Watt

they bring aspects of their past to the present and find new and creative ways to express themselves. In the words of Elizabeth Baker, former editor of *Art in America*, "tradition is no longer a burden, but a newly discovered resource" (Baker 1982, 5). Art historians Jean Robertson and Craig McDaniel state that "When we revisit history, time collapses; what was once present and is now past becomes vividly present once again. The present appears in a new context, and it becomes possible to see the present more critically through the past" (Robertson and McDaniel 2012, 59). In her essay in this volume, Charlene Holy Bear aptly notes: "The movement from traditional art to what is considered contemporary art is itself a circular motion through time. In other words, what is traditional was actually

contemporary at one time." This position is a variant of the observer effect, wherein the act of looking back changes what is looked upon.

Dan Swan discusses the physical movement of artworks themselves—through commerce, exchange, diaspora, and usage—as well as motion in the sense of change of status, as art objects shift from commodities to inalienable possessions to cultural artifacts. Although not elaborated on in this volume, motion can also come into play in the case of kinetic sculpture; I am thinking in particular of the transformation masks of Northwest Coast peoples (fig. 5). In their major work on contemporary visual arts, Robertson and McDaniel highlight the role of "time" in Northwest Coast masks and Navajo sand paintings, noting that these examples deal with time in

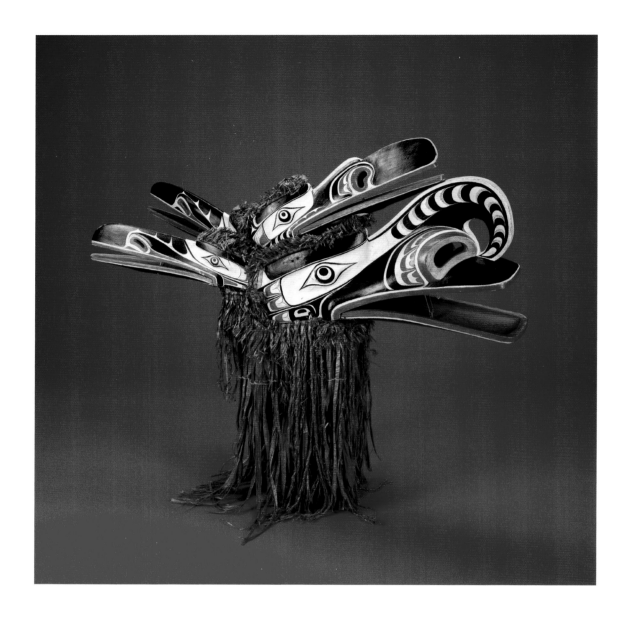

Fig. 5: George Walkus (Kwakwaka'wakw, about 1890–about 1950), **Four-faced Hamat'sa mask, about 1938.** Wood, paint, cedar bark, and string, 21 x 51 in. (53.34 x 129.54 cm). Denver Art Museum: Native Arts acquisition funds, 1948.229.

similar, yet different ways (Robertson and McDaniel 2012, 40–41). The masks' ability to transform from one visual expression to another through physical manipulation differs from the temporary, yet permanently changing, status of sand painting.

Art can also play a role, or act as a tool, in changing conceptual views, positions, and opinions, something Monkman points out when talking about his work. As in some of the other examples I've given, here too we have both figurative and literal movement. It is not just the viewer's opinions that may change; because of their monumental scale and their narrative style, Monkman's paintings require active motion on the part of the viewer, whose eyes must traverse the canvas to take in the scene. A focus on movement is also useful in addressing issues of representation. Images that acquire iconic status, like James Earle Fraser's *End of the Trail* or the photography of Edward S. Curtis, perpetuate stubbornly popular views of the defeated or stoic Indian that seem stuck in time. Monkman takes these images and playfully reanimates them. Similarly, Hollywood movies are famously guilty of perpetuating stereotypes, yet many native filmmakers have turned the tables and used film and video (as well as newer media technologies) to challenge these views, as Kristin Dowell notes in her essay. Finally, the lack of motion—a pause for reflection, or to notice a detail in an artwork—is just as applicable to this discussion as the other forms outlined here.

The authors in this volume come from different backgrounds and perspectives—they are artists, scholars, anthropologists, and art historians. The essays by Holy Bear, Minifie, and Monkman provide primary documents about their artistic practice that have not been recorded or presented like this before. The essays from Dowell, Jonaitis, and Swan present new directions in their scholarly research and, independent of this volume, are important contributions to their fields. I am struck by the creativity and insightfulness that all the authors exhibit in their responses to the theme of motion. Bringing all these perspectives and research together in one volume provides an opportunity to consider how diverse arts and cultural inquires share common elements when viewed through a framing lens.

REFERENCES CITED

Baker, Elizabeth. 1982. "Editorial: How Expressionist Is It?" *Art in America* 70 (December 1982): 5.

Robertson, Jean, and Craig McDaniel. 2012. *Themes of Contemporary Art: Visual Art after 1980*. New York: Oxford University Press.

Thompson, Robert Farris. 1974. *African Art in Motion: Icon and Act in the Collection of Katharine Coryton White*. Berkeley and Los Angeles: University of California Press.

———. 2011. *Aesthetic of the Cool: Afro-Atlantic Art and Music*. Pittsburgh: Periscope Publishing.

Altering Sight
Ideas in Motion

Kent Monkman

Most of my work challenges history, or rather, dominant versions of history: Western artists looking at indigenous art, indigenous people, indigenous cultures. To achieve this, I looked at individual Western artists to understand their personal motivations and also at larger bodies of work made in the past couple hundred years, especially the work of European artists who arrived here, observed indigenous cultures, and recorded what they saw. When I examined their work, I became more interested in what they did *not* see and what they misrepresented.

Empty Landscapes and Shifting Views of Gender

George Catlin (1796–1872) has been described as my nemesis, and I do tend to pick on him a lot, but I admire his work at the same time. When artists of the nineteenth century, particularly, looked at indigenous art, it was kind of a double-edged sword. On one hand they thought it was their duty to, as Catlin put it, "fly to the rescue of indigenous people," that is, to record native peoples as they were before they were contaminated by Western culture (Letter no. 2, "Mouth of Yellow Stone, Upper Missouri," in Catlin 1989, 11). At the same time, whenever Catlin encountered something that didn't suit his own social mores or values, he tended to edit or eliminate things from view, similar to the way photographer Edward S. Curtis constructed very romantic images of indigenous people.

Catlin's painting *Dance to the Berdache* has inspired me to produce a number of different artworks, and I start with this work because it is about sexuality and how Native American sexuality stood apart from the European binary of two genders, male and female (fig. 6). Europeans coming to North America encountered what the French referred to as the *berdache*, a male who lived as a female. This is what is referred to as the "third gender." It is the position between male and female genders. Catlin's painting, and what he says in his journal, have been very significant for me because they represent how our cultures and sexualities have been so heavily impacted through a colonial process of cultural obliteration.

My research led me to other painters of that period. I started to look at the beautiful, romantic, sweeping landscapes of Albert Bierstadt and painters of the Hudson River School, who were interpreting North America through a romantic lens. I felt that to engage with the authority of their work, I needed to rise to the challenge, expanding and stretching my own technical abilities to meet them with the same degree of skill and masterful painting they had inherited from the tradition of Western painting. There were a number of themes that came up in the work of the Hudson River School artists. They saw North America as a sort of paradise—a Garden of Eden (fig. 7). I wanted to challenge their work because

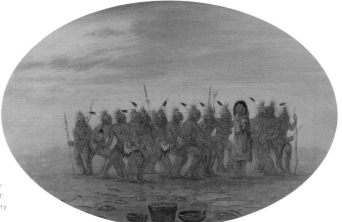

Fig. 6: George Catlin (American, 1796–1872), *Dance to the Berdache—Saukie,* **1861/1869.** Oil on card mounted on paperboard, 18½ x 24⅞ in. (47 x 63.2 cm). National Gallery of Art: Paul Mellon Collection, 1965.16.333. Courtesy National Gallery of Art, Washington, DC.

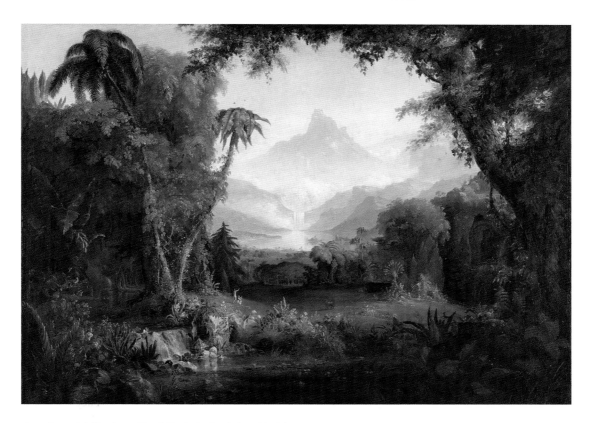

Fig. 7: Thomas Cole (American, 1801–1848), *The Garden of Eden,* **1828.** Oil on canvas, 38½ x 5¾ in. (97.8 x 134 cm). Amon Carter Museum of American Art, Fort Worth, TX, 1990.10.

they were depicting native people as static cultures, frozen in time and unable to move forward. As I created my work over the past ten years, I thought a lot about this concept of freezing native cultures in time; that we were perceived as unable to exist beyond a romantic ideal that was foisted upon us in the 1800s; that somehow if we did not always ride a horse and wear a feathered headdress we were no longer native people. That is something that contemporary indigenous people continue to struggle with: the need to assert to the dominant culture that we have moving, evolving, and innovative cultures. It's an unfortunate position to be in, to have to assert the concept that your culture is in motion and has always been moving forward.

One of the other themes that came out of that period was captivity narratives; in this case, native peoples as sexual predators. Karl Wimar's painting *Abduction of Daniel Boone's Daughter by the Indians* captures the sexuality inherent in this genre, and also another theme in my work: power relationships (fig. 8). I wanted to reverse the gaze and highlight how, as Indian people, we have been looking at you (white people) as long as you have been looking at us.

One of the first pieces I made in this genre is called *The Rape of Daniel Boone Junior* (fig. 9). In this case, I saw it more as liberation and a freeing of ideas on sexuality that were frozen in time. I wanted the youth in this painting to resemble a Tom Sawyer

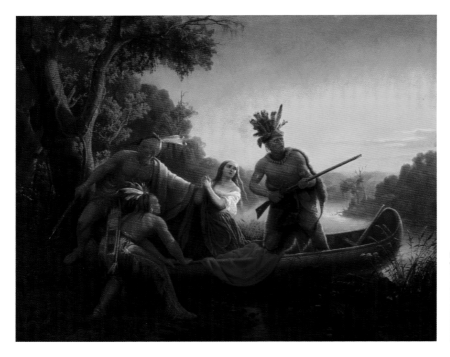

Fig. 8: Charles Ferdinand [Karl] Wimar (American, born Germany, 1828–1862), *Abduction of Daniel Boone's Daughter by the Indians*, 1853. Oil on canvas, 40⁵⁄₁₆ x 50¼ in. (102.39 x 127.63 cm). Mildred Lane Kemper Art Museum, Washington University in St. Louis. Gift of John T. Davis, Jr., 1954.

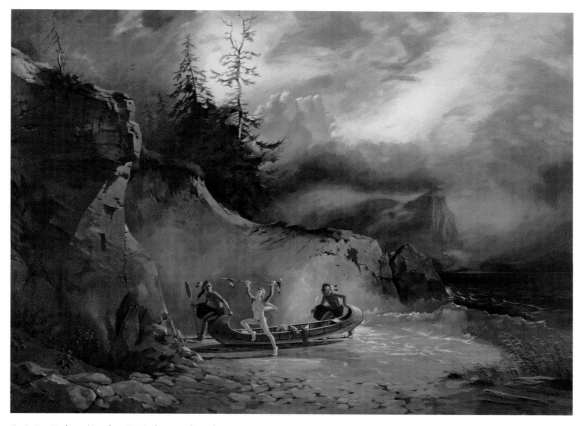

Fig. 9: Kent Monkman (Cree, born 1965), *The Rape of Daniel Boone Junior*, 2002. Acrylic on canvas, 18 x 24 in. (45.72 x 60.96 cm). Private collection. © Kent Monkman

or Huckleberry Finn character. Playing against the violence implied by the title of the painting, Daniel Boone Junior appears to be experiencing something more like an epiphany or liberation than a rape.

To enter into a dialogue with the romanticizing artists, I needed to learn more about them as individuals, so I took a close look at their careers and work. Painters like John Mix Stanley and George Catlin would paint themselves into their work as a mode of self-aggrandizement and self-

promotion (fig. 10). Now that I was working inside this idiom, I wanted to create an alter ego that could rival their egos, reverse the gaze, play inside the work, and be the artist's persona—but whose subject was Europeans.

I consulted a number of different sources for inspiration for my alter ego. I looked at We-wha, a Zuni *berdache*: he/she was a revered leader in her community and represented her nation in Washington, D.C. (fig. 11). I wanted to create my

17

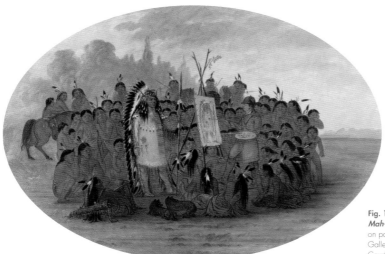

Fig. 10: George Catlin, *Catlin Painting the Portrait of Mah-to-toh-pa—Mandan*, **1861–69.** Oil on card mounted on paperboard, 18½ x 24 in. (47 x 62.3 cm). National Gallery of Art: Paul Mellon Collection, 1965.16.184. Courtesy National Gallery of Art, Washington, DC.

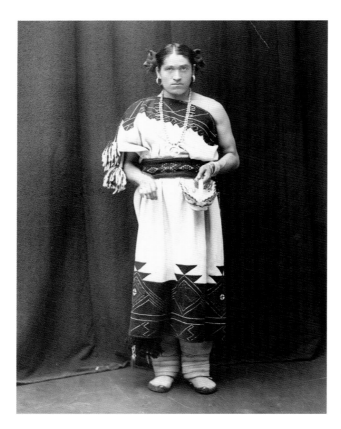

Fig. 11: John K. Hillers (American, born Germany, 1843–1925), *We-Wha, Zuni Pueblo, New Mexico,* **1879–80.** Courtesy of the Palace of the Governors Photo Archives (NMHM/DCA), 029921.

own *berdache* persona, a person of the third gender: an empowered person like We-wha, who could stand up to the white man, I guess you could say. Make pictures of HIM! Thus appeared for the first time my alter ego, Miss Chief Eagle Testickle (fig. 12). The name is a play on the words "mischief" and "egotistical"; therefore, it is about the massive ego of the artist, and how the artist often has to be relentlessly self-promoting. Miss Chief's outfit was inspired by the singer Cher. But before Cher there was Molly Spotted Elk, a Penobscot woman who danced for years in Paris revues (fig. 13). Between their two outfits, I arrived at my own version.

So, Miss Chief started rampaging through North American art history in my paintings, performances, and other works. Many of the paintings by Bierstadt that I used to stage my work were empty, which reinforced the idea that European Americans saw the West as a landscape devoid of indigenous people. Miss Chief inserts herself into many of those landscapes in a variety of bawdy, political, and mischievous narratives. In *Rebellion* (fig. 14) she seduces a Mountie, luring him with an apple into her canoe, which is stuffed with Louis Vuitton luggage (her favorite luxury brand). In several artworks, I not only reverse the gaze, but reverse the

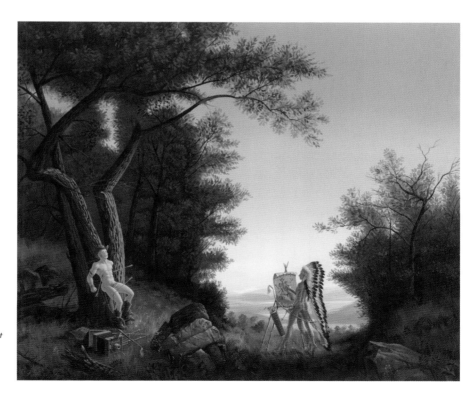

Fig. 12: Kent Monkman, *Artist and Model*, 2003. Acrylic on canvas, 20 x 24 in. (50.8 x 60.96 cm). Collection of the artist. © Kent Monkman

Fig. 13: Molly Spotted-Elk dressed
for a performance, 1928.
Photographer unknown. Image
courtesy of Molly's daughter,
Jean Archambaud Moore.

Fig. 14: Kent Monkman, *Rebellion*,
2003. Acrylic on canvas, 36 x 48 in.
(91.44 x 121.92 cm). Collection of
the Canada Council Art Bank.
© Kent Monkman

grief. In *Not the End of the Trail*, Miss Chief is grieving for her fallen lover—a white man (fig. 15). This work is based on a Frederic Edwin Church painting, *To the Memory of Cole* (1848, private collection) made as a eulogy to Thomas Cole, founder of the Hudson River School. In this painting Miss Chief is looking fabulous in her moment of romantic grief, while she glances seductively over her shoulder at a well-endowed native priest. I saw him as representing her future, or the future in general.

Her pose, and that of her pony, are based on James Earle Fraser's famous sculpture *End of the Trail* (1918). This sculpture, replicas of which are ubiquitous in the Southwest, is an iconic image that reinforces an obsession by non-natives with a romantic grief for native cultures that have reached the end of the road. This mythology was created by Europeans to celebrate the end of the North American Indian, and they fell in love with their romantic and tragic imagery of a dying race. In response, I created *Icon for a New Empire* to counter this debilitating myth (fig. 16).

At the same time that artists such as Karl Bodmer, Catlin, and others were collecting thousands and thousands of artifacts, extracting them from living,

Fig. 15: Kent Monkman, *Not the End of the Trail*, 2004. Acrylic on canvas, 72 x 108 in. (182.88 x 274.32 cm). Private collection. © Kent Monkman

Fig. 16: Kent Monkman, *Icon for a New Empire*, 2007. Acrylic on canvas, 108 x 84 in. (274.32 x 213.36 cm). Private collection. © Kent Monkman

breathing native cultures, they created images that locked native people in a time capsule. So many paintings of the nineteenth century celebrated, or at least reinforced, the commonly held belief that native people were a vanishing race. Unable to move forward, native people were believed to be overcome by progress. My art works to challenge these static images and provide a new way of seeing, while also moving the discourse on the past to topics and themes either avoided or silenced previously.

Moving Your Eye: How We See a Canvas

Sexuality is one of the themes that I explore in the once-empty landscapes created by artists such as Bierstadt. *Trappers of Men*, based on another Bierstadt painting, is very much about seeing (fig. 17).[1] How do we see the world around us? How do we interpret the land? The landscape here represents space and the illusion of space. Bierstadt was a master in creating the illusion of three-dimensional space on a two-dimensional surface. As a painter, that ability was a challenge that I wanted to achieve. *Trappers of Men* reflects on how land (and therefore landscape painting) is viewed and interpreted differently by indigenous and European settler cultures. As you move your eye from left to right across this canvas, you find there is an Edward Curtis character posing his models. One of his models is about to put on his wig. Next there is Miss Chief rising above the surface of the water, like a goddess or an apparition of beauty—a metaphor for creative epiphany. Centrally placed is Piet Mondrian, who stumbles back at this vision of beauty into the arms of Jackson Pollock (fig. 18). Mondrian's early abstractions were extracted from landscapes. Pollock was, of course, also an abstract painter, but he was heavily influenced by Native American sand painting. The drips that fly off Mondrian's brush further inspire Pollock. As you continue to move your eyes left to right

across the painting, there's my nemesis Catlin again, taking copious notes about a winter count. The winter count is a native form of recording or painting history. In my work I often use the bison hide, as a canvas, to represent a native version of history. In this case, there are one hundred years of history on Lone Dog's winter count: a glyph or symbol represents a single significant event for each year. When researching winter counts, I found it interesting that a theft of ponies made the record for the year that the Lakota defeated Custer; Custer himself did not rate, although he has become so huge in U.S. mythology. What a great example of how we select what's important as we tell our own version of history, and how history can fold both ways in terms of where we put our emphasis: what we leave in and what we leave out. I had to include Lewis and Clark with matching monograms on their lapels, arguing over their map. Letters between the two men suggest an unrequited love resulting in Lewis's suicide. Explorer Alexander Mackenzie on the far right struggles with his sextant. He failed to "discover" the Northwest Passage twice before he finally learned how to use his instruments. As your eye moves across the canvas, you begin to see the history of art and the histories of native peoples reconstruct themselves in new ways, to tell new stories and new truths.

Catlin's Morality

To return to the painting I opened the essay with: my version of Catlin's *Dance to the Berdache*, another sweeping panorama of historic and mythological characters. I titled this painting *The Triumph of Mischief*, and it features none other than Miss Chief as the *berdache* being honored by the men with whom she has had sexual relations (fig. 19). Essentially it is a riotous, orgiastic celebration of homosexuality in pagan cultures. I wanted to counter Catlin's cultural religious prejudices. Of

Fig. 17: Kent Monkman, *Trappers of Men*, 2006. Acrylic on canvas, 84 x 144 in. (213.36 x 365.76 cm), Collection of the Montreal Museum of Fine Art.
© Kent Monkman

Fig. 18: Detail of figure 17.

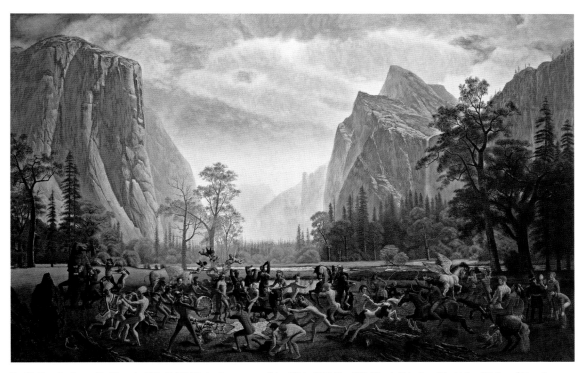

Fig. 19: Kent Monkman, *The Triumph of Mischief*, 2007. Acrylic on canvas, 84 x 132 in. (213.36 x 335.28 cm). Collection of the National Gallery of Canada. © Kent Monkman

the actual dance to the *berdache* in the Sac and Fox Nation that Catlin depicted in his painting, he wrote that it was "one of the most disgusting and unaccountable things" that he'd ever seen, and he "wished for it to be extinguished before it be more fully recorded" (Letter no. 56, "Rock Island, Upper Mississippi," in Catlin 1989, 445). I'm so grateful that despite his strong objections, he validated the importance of the dance by making his painting. In response, my version was created to celebrate homosexuality. The scene is populated by braves, centaurs, satyrs, a minotaur, and a buffalo dancer, highlighting the existence of homosexuals across time and place,

culture and religion. It features Duchamp as well as Picasso, who borrowed heavily from Oceanic cultures, and Paul Kane, a Canadian who, like Catlin, set out to document indigenous cultures with his portraits, paintings, and drawings of indigenous life. Here Catlin, obsessed with his own image, muses on his refection in a mirror. Both Catlin and Kane are dressed in Indian buckskins. It was fine for them to culturally cross-dress, but they both wrote about how they despised it when their native subjects wore Western clothing.

This disdain for how native cultures responded to the influence of Western culture led Catlin to draft

a "moral schema" (Catlin 1866). Catlin painted a before-and-after portrait of an individual named Pigeon's Egg Head, showing his "pure" state and his "contaminated" state (fig. 20). Catlin used this portrait as a moral lesson on how the native person must remain pure and must not incorporate or accept European influence. In his moral schema, Catlin actually assigned some very simplistic before-and-after traits to native people: they were handsome (before contact) and became ugly (after contact); virtuous, then libidinous . . . and so on. His writing gives real insight into the prejudices of his time; and under the auspices of Catlin's pseudo-scientific research, it is quite simply a racist document. You can see why George Catlin is my nemesis. Much of my art actively works to alter viewers' perceptions of native people in the past, as well as in the present. The history books do not privilege native voice, so I use my art to bring us back to where it all went wrong and begin to retell these stories.

Catlin made hundreds of paintings of chiefs and high-ranking warriors and braves, but he also wrote about beautiful, flamboyant men that he encountered in every tribe and described them in his journals as dandies: "their own people referred to them as 'faint hearts'" (Letter no. 16, "Mandan

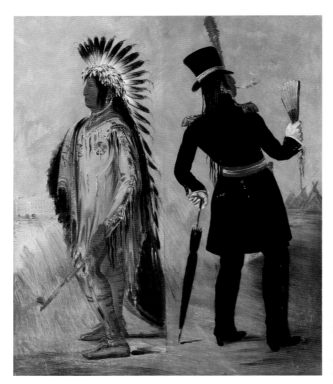

Fig. 20: George Catlin, *Wi-jún-jon, Pigeon's Egg Head (The Light) Going To and Returning From Washington*, 1837–39. Oil on canvas, 29 x 24 in. (73.6 x 60.9 cm). Smithsonian American Art Museum: Gift of Mrs. Joseph Harrison, Jr., 1985.66.474. Courtesy Smithsonian American Art Museum, Washington, DC/Art Resource, NY.

Village, Upper Missouri," in Catlin 1989, 110). In one of the Mandan villages where he was making these portraits, he described gentlemen who spent the entire day working on their outfits. They weren't warriors or chiefs. They didn't go out on the hunt for big game like bison and bear. They would catch the lesser animals, the squirrels and the rabbits, and fashion incredible outfits from them. Naturally, he wanted to make portraits of these beautiful dandies who were presenting themselves to him, and, because they were vain, they were vying to have their portraits painted. Catlin considered them to be spectacular subjects, and he began to chalk out a portrait of a particularly handsome specimen. He scarcely had it all chalked out on the canvas when the ranking warriors and braves and chiefs of the tribe—who had status from war deeds and hunting exploits—expressed their opposition to Catlin validating this lesser person with a likeness. Catlin's entry and access to the nobility of the tribe was a privilege predicated on his skills as a portraitist. (Catlin also wrote about the awe that his portraits inspired and his status as a shaman in the eyes of the native people; see letter no. 15, "Mandan Village, Upper Missouri," in Catlin 1989, 103-5.) He was not authorized to make portraits of just anyone in the tribe; it was considered a special honor restricted to tribal members of rank and status. Catlin erased his chalk sketch, and the beautiful flamboyant dandies never got painted. The erased sketch, and the countless other beautiful "faint hearts" who exist only as colorful descriptions in his diaries, stand for me as metaphors of countless erased histories in native North America. I imagined them in a series of paintings, and I saw them as the fashion-forward gentlemen of the tribe.

After exploring how "faint hearts" were omitted from Catlin's art, I began to look for the inclusion of careful attention to the depiction of their styles of dress and accessories like the parasol in native arts. I came across ledger drawings made by Kiowa and Cheyenne warriors incarcerated during the Indian Wars at about the same time that Catlin, Kane, and others were documenting native peoples (fig. 21). The native artists include parasols as accessories in their drawings of their own people. You never see a native person with a parasol in a Catlin or Kane painting, excepting the furled umbrella in Catlin's portrait of Pigeon's Egg Head, a painting the artist viewed as a moral lesson in cultural contamination. Parasols were modern trade items that were used widely at that time, so the dandies in my paintings often have parasols. The chalked-in dandy characters with top hats and parasols lurk like ghosts behind Catlin's warrior and chief portraits (fig. 22). They wait patiently to be noticed, drawn, or photographed, and never get their moment in the sun. As I imagined these dandies, I designed a line of clothing, a mash-up of top hats, thigh-high suede

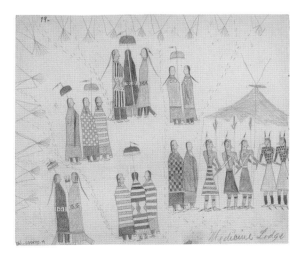

Fig. 21: Cheyenne artist's drawing of Sun Dance ceremony, 1875. National Anthropological Archives, Smithsonian Institution [NAAINV 08547019].

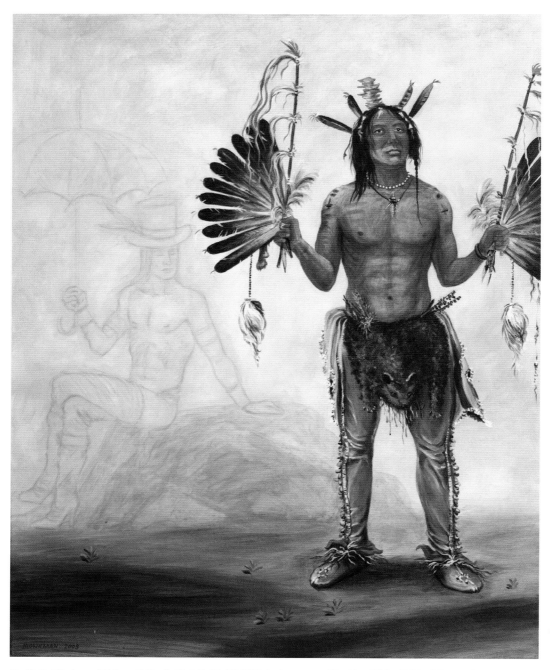

Fig. 22: Kent Monkman, *Old Bear with Tinselled Buck No.10, 601*, 2008. Acrylic on canvas, 30 x 24 in. (76.2 x 60.96 cm). Private collection.
© Kent Monkman

boots, and fur stoles. I began with watercolor sketches so I could more freely imagine how fabulous they would look (fig. 23). In the larger paintings they pose languidly in front of a painter, ostensibly Bierstadt or Thomas Moran, who is painting a vacant landscape (fig. 24). In some paintings they resemble wildflowers: gorgeous expressions of color and sensuality.

Using Motion to Challenge Static Views

Many of the themes I explore in my two-dimensional paintings continue in other media. The movement of ideas comes to life in my performance art and dance-based video and installation art. In these, I literally use motion and movement to challenge static views of the past and to highlight the dynamic reality of native cultures.

I have created a number of multimedia installations pieces that use the tipi as a basis for inspiration. *Salon Indien* (2006) is a velvet tipi that I turned into a movie theater (fig. 25). In this work, I show video, that is, moving images, inside the tipi. The video is projected from a central chandelier onto a canvas representation of a bison hide on the floor. Similar uses of video components are found in other works of mine, such as *Théâtre de Cristal* (2007), which features a two-channel version of my film *Shooting Geronimo* (2007) projected down into an open and transparent space where you can go in and watch the videos and still view the paintings and accompanying text on the wall. In this case the projections are oriented in four directions so you can watch them from all angles. Using video allowed me to create, almost like a diorama, a space where Miss Chief had a presence but was no longer present. That said, the incorporation of video added a dynamic element to the otherwise static work.

Catlin's *Dance to the Berdache*, as described previously, furnished the inspiration and title for a

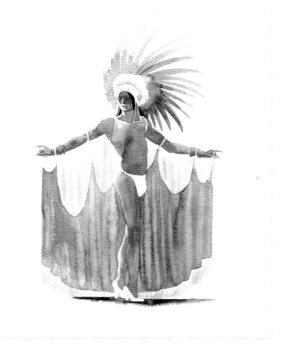

Fig. 23: Kent Monkman, *Faint Heart 27,148*, 2008. Watercolor on paper, 12 x 9 in. (30.48 x 22.86 cm). Private collection © Kent Monkman

five-channel video piece that imagines Miss Chief, as the *berdache*, as the recipient of an honor dance (fig. 26). Four dancers, garbed as dandies with parasols, represent spirits from the four cardinal directions. Four beautiful native dancers, dressed how I like to think native dandies looked: parasols, PVC leggings, body paint, and top hats. When installed, the four dancers appear on four rear projection screens that are shaped like large bison hides; these are oriented around a central, fifth hide where Miss Chief appears. It's an immersive installation—the audience can walk into the space and move around the hides and experience the music and sound design. I remixed Stravinsky's *Rite of Spring* with

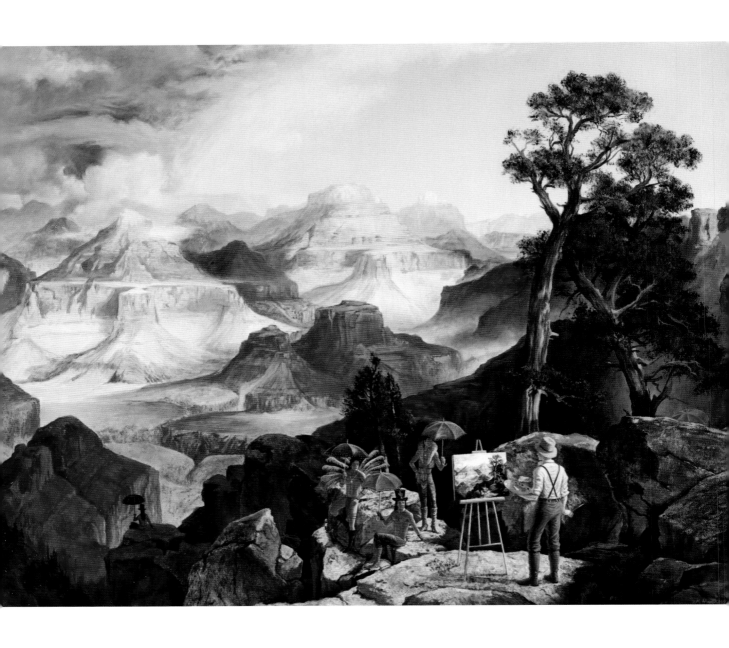

Fig. 24: Kent Monkman, *Clouds in the Canyon,* **2008.** Acrylic on canvas, 62 x 84 in. (157.48 x 213.36 cm). Private collection. © Kent Monkman

techno music and traditional powwow vocals, so it's a real mash-up. *The Rite of Spring* was an exploration of primitivism, so I wanted to refute the modernist tenet that indigenous cultures are primitive while also using moving images to refute the idea that they are static. There are a number of sequences in the piece that construct a narrative involving an act of creation, a call to the dance, a hunt, a presentation of a ritual gift, and finally an honor dance. It is a cycle of regeneration. Miss Chief's hand moves across the other four hides simultaneously as she draws four pictographs that animate, then morph into live action of the dancers. It ends with the dancers encircling her. With special-effect animation, they invigorate her with bolts of energy and then return to dust before the cycle begins again. The piece is about how our artists, our creativity, are the motion in our cultures that keeps them renewed and alive.

Museums

As part of my work, I often explore museology: how have native people been represented in museums? Why do museums continue to present ours as static cultures? We are often relegated to the native art section even if our work is nontraditional and contemporary. I have experienced this over and over

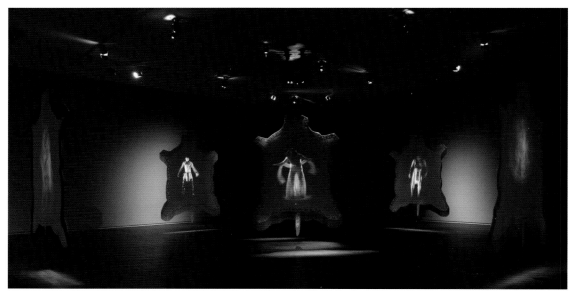

Fig. 26: Kent Monkman, *Dance to the Berdashe,* 2008 (installation view and stills). Multimedia installation, dimensions variable. Montreal Museum of Fine Arts © Kent Monkman. Installation view by Christine Guest; stills by Chris Chapman.

again. It continues to confound me, so I make work in response to it.

In 2007, I was part of a group exhibition at the Royal Ontario Museum that was curated by two young Aboriginal curators. All of us contemporary native artists were encouraged to create works in response to, or engaged with, the museum's collection. I jumped at the chance because I like to go into a museum collection and look at everything, not just native art or works relating to native subjects. I look at classical sculpture, classical painting, and find relationships. It's a wonderful way of opening up a dialogue about my own perspective and finding differences as well as similarities between art practices from different times and cultures.

At the Royal Ontario Museum there is a First Peoples gallery, and naturally I went there first to see the Paul Kane paintings. As I mentioned previously, his subject and area of interest was, like Catlin, native peoples. I became interested in his painting *Medicine Mask Dance* (fig. 27). In this work he depicts naked Aboriginal men dancing and wearing masks. All of these masks existed in real life and can be identified with a number of different tribes; however, they would never be seen or used together like this, so his painting is complete fiction. I proposed to the

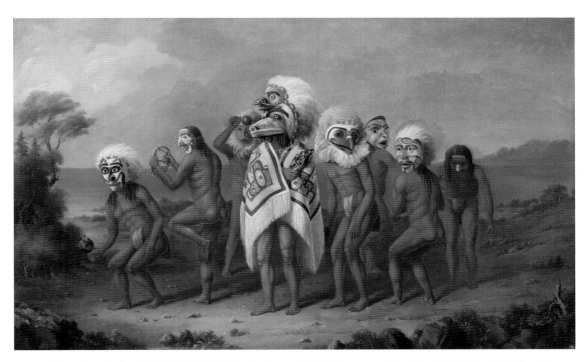

Fig. 27: Paul Kane (Canadian, born Ireland, 1810–1871), *Medicine Mask Dance,* **1848–56.** Oil on canvas, 17 ⅞ x 29 in. (45.3 x 73.8 cm) Royal Ontario Museum. The Honourable George William Allan Collection, Gift of Sir Edmund Osler, 912.1.92. With permission of the Royal Ontario Museum. © ROM

museum and to the contemporary curators that I make my own painting, to bring awareness to Kane's liberal use of artistic license. I would then hang my painting next to Kane's inside the First Peoples gallery. What I did not expect was that I was forbidden to show my work in the First Peoples gallery, and the curator of the First Peoples gallery put forward a number of excuses. Some interesting emails ensued between the curator of the First Peoples gallery, the museum's director, and me. Ultimately, the curator of the First Peoples gallery said, "I *cannot* allow you to challenge Paul Kane's work to our viewers. But, I will allow the contemporary curators to borrow the original painting and show it in the contemporary gallery."[2] So this is what we did. But, being a rather devious person, I came up with the idea, and the contemporary curators encouraged my idea, to create a performance in response to being banned from the First Peoples gallery. The painting that I made was based on Jean-Léon Gérôme's *Duel After the Masquerade* (1857–59, Walters Art Museum, Baltimore). I like the idea of the scene being a duel. I like the idea that the victor was dressed like an Indian, or *is* an Indian. In my version of *Duel After the Masquerade*, Miss Chief has kicked over Paul Kane's easel with her high heels and is marching away, clearly indignant (fig. 28). Kane is being supported by some Caucasian men wearing the masks depicted in his own painting, and in the background we see Paul Kane's house in Toronto, now at the center of our gay village.

Issues of Representation

I have been fascinated with the museum as a repository of native culture, but also with the limitations and problems that come with representation. Much of my current work explores the museum diorama as an idiom to engage not only with art history, but also museology. How can museums address indigenous cultures as non-static cultures? There are several examples of wonderful lifesize dioramas of Aboriginal life at the Manitoba Museum in Winnipeg (fig. 29). I grew up going to this museum on school trips, alternately fascinated and disturbed by the experience. Inside the museum I felt pride in experiencing (with my mostly non-native classmates) indigenous cultures displayed in their ideal state—frozen in time, beautiful yet remote; and conversely, stepping outside the museum I felt the shame of the reality for many Aboriginal people in Winnipeg: the poverty and the skid row of Main Street, the fallout of the colonial experience, broken people, and addiction. When I grew up there, in the 1970s, Winnipeg was rigidly stratified into distinct neighborhoods with racial and socio-economic divisions. The north end of Winnipeg is where the city's highest number of native people lived and still live today, mostly in poverty and rising violence.

In 2011 I was in a group exhibition at Plug In ICA in Winnipeg. The curators wanted to create an exhibition of contemporary native artists with a vision of the future to deliberately propel native people not just out of the past but the present as well. The first thing I thought of was the Manitoba Museum, and I jumped at the opportunity to create a museum diorama. I immediately thought of Miss Chief as an aging diva exiled to her room in Paris after the end of her performance career. It's just a corner of a Parisian apartment where the lonely diva sits gazing out her window (fig. 30). The view through the window is an idyllic pastoral scene—one of my paintings, actually. Inside the room are taxidermy animals. A beaver chews the leg of a record player. The needle on the record is stuck at the end, and all you hear is the clicking and static of the record turning and turning. Like Maria Callas at the end of her career, Miss Chief has been listening to her own record, in this case, *Dance to Miss Chief,*

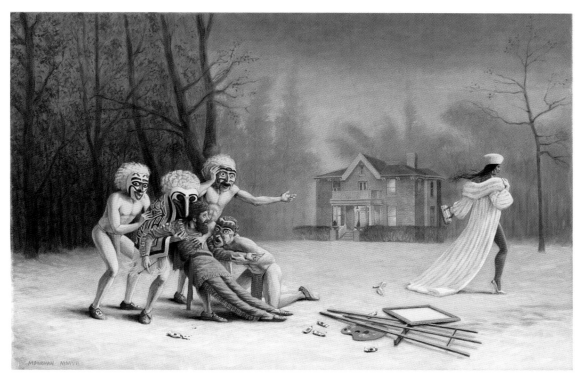

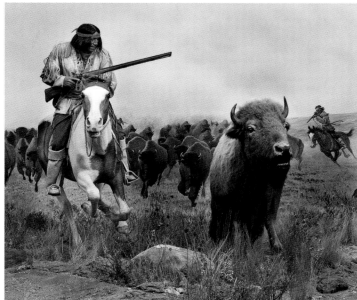

Fig. 28 (above): Kent Monkman, *Duel After the Masquerade*, 2007. Acrylic on canvas, 20 x 30 in. (50.8 x 76.2 cm). Private collection. © Kent Monkman

Fig. 29 (right): Bison diorama from the Manitoba Museum (detail). Image © The Manitoba Museum, Winnipeg, Manitoba.

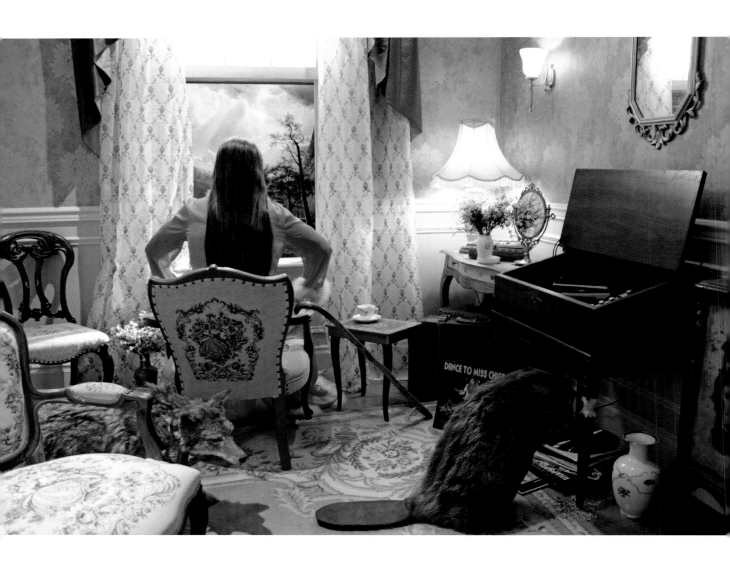

Fig. 30: Kent Monkman, *The Collapsing of Time and Space in an Ever Expanding Universe*, 2011 (installation view). Multimedia installation, 21 x 14 x 16 ft.
Collection of La Maison Rouge, Paris. © Kent Monkman

her one hit. (This is a piece of music I had commissioned for the performance I did in 2007 at the Royal Ontario Museum, *Séance*, as a response to being banned from the First Peoples gallery. *Séance* includes a five-channel soundscape that invokes a feeling of melancholy and collapses the boundaries of reality, imagination, and memory.)

Titled *The Collapsing of Time and Space in an Ever Expanding Universe*, my installation evokes questions such as: are these animals Miss Chief's pets or are they spirits? Are the sounds we hear just from her imagination? The sound of nature drifts through the window and around the room—about thirty minutes of sound from the Canadian wilderness. Inside you hear the ticking of a broken clock that gets louder and louder and louder, emphasizing the suspension of time. About every five minutes you hear a low rumble that gets louder; it's like thunder, but it also sounds like the Paris Metro. When you move around behind the space you encounter the painting and you see Miss Chief on her Indian paint pony mingling with the placid bison—a direct reference to the bison diorama at the Manitoba Museum. The view through the window back into the room is almost like looking at a religious icon: you see Miss Chief crying as she gazes longingly out the window. Her mascara is running (the mannequin is fitted with a water pump and she cries real tears). Every minute or so, if you stand and wait for it, a little tear drops out of each eye.

This work challenges the viewer's ideas of time by focusing on the moment. It causes you to think about what has occurred before, leading to this moment, and what is yet to come. Motion is not only about constant movement. A pause or reflection can create a spotlight on those things that are always in motion, such as life, careers, and aging.

NOTES

Considering the various media I work with and the notions of time, shifting power dynamics, and live and video performance, motion proves to be a central theme that helps to facilitate discussions and understanding of my art. This opportunity to present my work in writing in such depth provided me a way to communicate my ideas and the trajectory of my artistic development. Challenging early depictions of Aboriginal people by non-natives and presenting alternate narratives is important to me, and I appreciate the opportunity to contribute to the discussion of the organizing theme of motion.

[1] The painting is *Among the Sierra Nevada, California*, 1868, at the Smithsonian American Art Museum, Washington, D.C.

[2] For more about these events, see Kerry Swanson, "Indigenous Art in the Museum Context: An Exhibition and Analysis of the Work of Kent Monkman," http://digital.library.ryerson.ca/islandora/object/RULA%3A3095/datastream/OBJ/view.

REFERENCES CITED

Catlin, George. 1866. *Letters and Notes on the Manners, Customs, and Condition of the North American Indians*. Vol. 2, Appendix C. Tenth edition. London. H. G. Bohn.

———. 1989. *North American Indians*. Edited and with an introduction by Peter Matthiessen. New York: Viking Penguin.

Experimental Digital Media on the Cutting Edge

Kristin Dowell

In what ways do Aboriginal filmmakers push the boundaries of media art while integrating technology in the service of Aboriginal cultural traditions? In this essay I aim to give the reader a sense of the range of Aboriginal Canadian experimental video and media art as I explore the common themes of politics, land, language, and identity that carry through this diverse body of work. Aboriginal media art is particularly vibrant in Canada, thanks to more than forty years of state support and a distinctive network of artist-run centers. From Alanis Obomsawin's filmstrips for the National Film Board of Canada in the 1970s to the latest online interactive new media works, Aboriginal media makers have remained at the cutting edge, integrating media technologies with Aboriginal cultural protocols and aesthetic traditions.

Aboriginal media artists, like other media artists, take advantage of the inherent qualities of motion within digital media to enhance and experiment with the formal aesthetics of their media. Manipulating the on-screen image through editing and post-production techniques, media artists rely on repetition, split screen, superimposition, reverse motion, distortion, and visual and audio effects to add texture and layering to their on-screen media aesthetic. Yet, Aboriginal media artists also draw on cultural traditions, Indigenous languages, and artistic practices from the Aboriginal nations in which they are citizens. Digital media provides a

powerful venue for media artists to raise visibility for the presence of Aboriginal people in Canadian society and to find new ways to articulate indigeneity in the twenty-first century. Throughout this chapter I argue that the work of Aboriginal media artists articulates visual sovereignty—a concept that I define as the expression of Aboriginal peoples' cultural traditions, political status, and collective identities through aesthetic and cinematic means. Analyzing the work of three Aboriginal media artists, I provide an introduction to the innovative and unique cinematic visions of Aboriginal media artists while exploring the theme of motion within their artwork and the common threads of land, language, and identity.

Visual Sovereignty

Aboriginal sovereignty represents the distinctive political status that derives from Aboriginal peoples' ties to lands prior to colonization. Sovereignty references a variety of domains in Aboriginal life, from cultural to political to spiritual, and also, I would argue, to the domain of media production. I contend that Aboriginal filmmakers' act of creating a media work is an act of self-determination (Dowell 2013). Speaking back to the legacy of misrepresentation in dominant media is an act of cultural autonomy that reclaims the screen to tell Aboriginal stories from Aboriginal perspectives. Aboriginal sovereignty is not only a political act, but also a cultural

process taking shape in and through Aboriginal media. As film scholars Michelle Stewart and Pamela Wilson assert, "In this landscape, control of media representation and of cultural self-definition asserts and signifies cultural and political sovereignty itself" (Stewart and Wilson 2008, 5). Artists and filmmakers express Aboriginal sovereignty and self-determination through the production of their art and media. For Tuscarora scholar and artist Jolene Rickard, the concept of visual sovereignty is the representation of Indigenous self-determination, cultural traditions, and aesthetics through visual forms. She declares, "Today, sovereignty is taking shape in visual thought as Indigenous artists negotiate cultural space" (Rickard 1995, 51). Aboriginal media can express visual sovereignty through the creation of Aboriginal film aesthetics, the ways in which cultural protocol is incorporated into media production, or the inclusion of Aboriginal media in domains, such as the broadcasting system, that have been predominantly Euro-Canadian.

Cultural Frameworks and Canadian Institutions

Before delving into the work of these filmmakers, I believe it is important to acknowledge that Aboriginal media makers in Canada have long been at the forefront of the global Indigenous media movement. The Canadian government—largely in an effort to support Canadian cultural sovereignty in opposition to the dominance of American media—has offered state support for Aboriginal media production since the late 1960s. The world's first national Indigenous television channel—APTN (Aboriginal Peoples Television Network)—launched in Canada in 1999, and Aboriginal media makers have produced everything from community documentaries to critically acclaimed and financially successful feature films. There are important

institutional frameworks in Canada, such as the Canada Council for the Arts, National Film Board of Canada, and artist-run centers, that have helped Aboriginal experimental media to flourish. While media art differs from other "traditional" or object-based Indigenous art practices, I highlight the ways in which Aboriginal media artists draw on the cultural and aesthetic traditions of their nations in their production practices. Although media art has often not received the same attention as other Native art practices, it does take its place alongside other art forms in galleries, film festivals, and artist-run centers.

Artist-run centers are invaluable institutions that have contributed to the rise of Aboriginal experimental video and new media. Run by a board of practicing artists, artist-run centers are non-profit art organizations that exist as alternative exhibition venues outside the commercial art market. These centers typically provide training, financial resources, access to equipment, and key exhibition space for artists. Scholar and media artist Dana Claxton writes of the significance of artist-run centers to Aboriginal new media art: "The discourse that developed, and continues to evolve in these independent production centers, concerns cultural production, race and gender politics, and the ideological and economic power of mainstream media . . . These venues were envisaged as venues for producing video as art, as opposed to commercial television" (Claxton 2005, 18). Artist-run centers that have been particularly supportive of Aboriginal media art include the grunt gallery, Western Front, and VIVO Media Arts Centre in Vancouver; Urban Shaman gallery in Winnipeg; the Banff Centre; the Galerie SAW Gallery in Ottawa; and Vtape in Toronto. Another key factor in the development of Aboriginal media art in Canada is the role that

established artists play in mentoring younger generations of filmmakers. Artists such as Dana Claxton, Thirza Cuthand (fig. 31), Steven Loft (fig. 32), Zachery Longboy, Mike MacDonald (fig. 33), Shelley Niro, Archer Pechawis (fig. 34), and Cease Wyss were pioneers in the early years of Aboriginal media art who have helped to support and mentor younger artists. There is a long history of Aboriginal media art in Canada, and this chapter can only provide a glimpse into this world; those interested in a fuller discussion are directed to *Transference, Tradition, Technology: Native New Media Exploring Visual and Digital Culture* (Townsend et al. 2005) and *Coded Territories: Tracing Indigenous Pathways in New Media Art* (Loft and Swanson 2014).

Aboriginal Experimental Media

Avant-garde film has been defined by scholar Michael O'Pray as work "characterized by unorthodox and experimental methods" (O'Pray 2003, 2). Film scholar William Verrone expands upon this definition, describing avant-garde film as "something *different*—a work that is antithetical to the mainstream, is produced outside economic and cultural channels of discourse, is (sometimes) deliberately political in nature, and is uniformly diverse in its multiple variations and forms" (Verrone 2011, 18). These definitions of avant-garde film focus primarily on the on-screen aesthetics and techniques of production.

I characterize Aboriginal experimental media as avant-garde both in the ways in which Aboriginal media makers experiment with on-screen aesthetics and in the innovative and sometimes unconventional off-screen production practices. There are similarities between Aboriginal experimental media and non-Aboriginal avant-garde films. Indeed, Aboriginal experimental media in Canada are often shown alongside non-Aboriginal experimental

media in art galleries and artist-run center settings. There are parallels in aesthetic style—editing, framing, superimposition, montage, repetition, and split screen—between Aboriginal and non-Aboriginal avant-garde media. However, I see several key ways in which Aboriginal experimental media differ from Western, non-Aboriginal avant-garde film and video. First, Western avant-garde film places a strong emphasis on the individual director—the auteur who creates a unique personal cinematic vision through his or her films. This is reflective of the larger privilege in the Western art world accorded to the individual (predominantly male) artist, and also reflects the Western modernist, capitalist sensibility that focuses on the autonomous individual disentangled from the weight of obligation to family and kin. In contrast, in Aboriginal experimental media the filmmaker often positions herself as an individual enmeshed in a complex set of obligations to social relations, extended family, and clan and community ties. Native films certainly reflect the unique and individual artistic visions of their makers, but they also emphasize their positions as individuals with ties to family, kin, community, and Aboriginal nations. Honoring cultural protocol is ultimately about respecting social relationships and obligations to family, clan, or community. This is quite a different approach to filmmaking than the Western emphasis on individual ownership, authorship, and personal vision.

Second, Western avant-garde film often emphasizes a break from tradition, articulating a modernist vision of a split from the past. Verrone describes the style of avant-garde film as "standing in opposition to tradition" (Verrone 2011, 17). Instead of rejecting tradition, Aboriginal filmmakers seek to honor their past and often place their cultural traditions center stage, by integrating cultural protocols and Indigenous aesthetics into their films while

Fig. 31 (upper left): Thirza Cuthand (Plains Cree, born 1978), still from *Helpless Maiden Makes an "I" Statement,* **2000.** Video, 6:12 min. © Thirza Cuthand

Fig. 32 (upper right): Steven Loft (Mohawk), still from *2510037901,* **2000.** Video, 3 min. Courtesy of Steven Loft and Vtape.org © Steven Loft

Fig. 33 (left): Mike MacDonald (Mi'kmaq, 1941–2006), still from *Electronic Totem,* **1987.** Video, 20 min. Courtesy of the Estate of Mike MacDonald and Vtape.org © Estate of Mike MacDonald.

Fig. 34 (above): Archer Pechawis (Plains Cree, born 1963), still from *Horse,* **2001.** Video, 9:52 min. Courtesy Archer Pechawis and Video Out Distribution © Archer Pechawis

contextualizing their work in the broader matrix of Aboriginal histories. Lastly, Western avant-garde film has been defined by its capacity to instigate active spectatorship and to invite audience members to rethink what the medium of film is capable of. "The avant-garde filmmaker radically reexamines the creative process, asking questions of the medium itself. What can film do? What can film accomplish?" (Verrone 2011, 10). Aboriginal experimental filmmakers fundamentally reimagine the possibilities of film by placing media technologies in the service of Aboriginal cultural protocols, aesthetic traditions, and stories, thus expressing Aboriginal visual sovereignty. Likewise, their films may demand interactive spectatorship and place the viewer in a position to witness on-screen explorations of Aboriginal social, political, and cultural issues and thus to recognize Aboriginal rights and cinematic expression on Aboriginal terms. This disrupts the notion of a unilinear trajectory for Aboriginal media production and reflects the diversity of practice within Aboriginal media. Aboriginal experimental media makers not only innovate within the field of Aboriginal media, they also make unique contributions to the broader genre of avant-garde film.

Confronting Settler Colonialism through Media

Now that I have established some background context, I would like to move on to the topic central to this symposium, examples that illustrate the way in which Aboriginal media artists creatively exploit motion within their media art. I begin first with an early example from Lakota media artist Dana Claxton called *I Want to Know Why*. Claxton is an interdisciplinary artist who is a central figure in the avant-garde and experimental media scene in Vancouver. She has mentored numerous Aboriginal artists, served as a founding board member of the Indigenous Media Arts Group, has been deeply involved with several artist-run centers, and is an associate professor of visual art at the University of British Columbia. Her critically acclaimed and award-winning art practice extends from experimental video to installation art to performance art. She grew up primarily in Moose Jaw, Saskatchewan, and her family reserve is the Lakota First Nations Wood Mountain Reserve. Her family is descended from Sitting Bull's followers, who fled persecution from the U.S. Army in 1877 after the fallout from the Battle of the Little Bighorn, escaping across the border into Canada. Her media work confronts Canadian and American colonial histories, questioning the devastating impact of these policies within Aboriginal communities. Her media work also examines Aboriginal relationships to the land and reflects Lakota spirituality and cosmology. Some of Claxton's most prominent videos include *The People Dance* (2001), which examines the importance of dance within Lakota cultural life; *The Red Paper* (1996), a critique of Canadian colonization and relationships with Aboriginal peoples; *The Hill* (2004), an exploration of the tricky entanglements between Aboriginal people and the Canadian government; and a quirky look at the racial and sexual politics of the appropriation of Indian iconography by burlesque dancers in the 1930s and 1940s in her film *Her Sugar Is?* (2009). Her filmography also includes video documentation of performance art works including *Tree of Consumption* (1994), a look at the environmental impacts of consumerism; and *Buffalo Bone China* (1997), an interrogation of the colonial practice of hunting buffalo, sacred to the Lakota way of life, to make bone china.

Claxton's powerfully intense black-and-white experimental video *I Want to Know Why* (1994) is an excellent example of the political dimension and the centrality of kinship within Aboriginal experimental video (fig. 35). This video critically examines

the intergenerational legacy of colonization through the life histories of Claxton's great-grandmother, who escaped into Canada with Sitting Bull, and her grandmother and mother, both of whom died at a young age as the result of living under colonial oppression in conditions of poverty.

Relying on repetition, split screen, and audio manipulation, Claxton exploits the capabilities of motion inherent in video technology to juxtapose images of icons such as the Statue of Liberty with archival photographs of her ancestors while Claxton's voiceover implores, "Mastincala, my great-grandmother, walked to Canada with Sitting Bull. Mastincala, my great-grandmother, walked to Canada starving. And I want to know why!"

followed by "Pearl Goodtrack, my grandmother, died of alcohol poisoning in a skid row hotel room. And I want to know why!," and then "Eli Goodtrack, my mother, OD'd at the age of thirty-seven. And I want to know why!" As the voice repeats this trio of questions four times during the film, it grows from "a whisper to a scream" (Bell 2010) as Claxton's anguished voice shouts, "And I want to know why!!" Claxton is literally screaming back against this painful history and legacy of settler colonialism that speaks to the specific Lakota history of her family, while also speaking to the broader Aboriginal experience of the ongoing legacies of settler colonialism. This powerful video confronts the horrific traumas faced by Aboriginal

Fig. 35: Dana Claxton (Hunkpapa Lakota, born 1959), still from *I Want to Know Why*, 1994.
Video, 6:20 min. © Dana Claxton

women as the result of policies of American and Canadian settler colonialism. Discussing this intergenerational impact on her own family in an interview, Claxton explained that, "For my mother's generation the life expectancy for Aboriginal people was thirty-eight. That wasn't because people just happened to die young. It was because of the brutalities of Canadian government-sanctioned oppression. It was all part of a system that harmed people" (Dowell 2013, 142–43).

In *I Want to Know Why,* Claxton generates a unique cinematic vision utilizing experimentation in the visual track with split screen, repetition, reverse imaging, and motion effects while also experimenting with the soundtrack, composed by Stl'atl'imx musician Russell Wallace, which provides a contemporary electronic dance beat under the voiceover. *I Want to Know Why* remains a strong example of the inventive ways in which Aboriginal experimental filmmakers creatively engage the capabilities inherent in moving-image technology in the service of Aboriginal histories and stories, articulating an effective critique of settler colonialism while simultaneously expressing a unique Aboriginal cinematic vision.

The Centrality of Land

A critique of colonial histories and a reflection of Indigenous cosmology are also evident in the work of Loretta Todd (Cree-Métis), a leader in Aboriginal media whose career spans an impressive range, from documentary videos for Native organizations to experimental art installations to feature film production. Her films address Aboriginal social memory, history, resistance, and cultural continuity in the face of colonization. She has been at the forefront of integrating experimental media techniques into the documentary genre. Her earliest feature-length documentary, *The Learning Path* (1991), examined

the devastating impact of the residential school system on Native children, while *Forgotten Warriors* (1997) tells the story of Aboriginal soldiers serving in the Canadian army in World War II—during a time when Aboriginal people were not granted Canadian citizenship—who returned home to face discrimination and lack of recognition for their service. In *Hands of History* (1994), Todd creatively explored the unique artistic practice and cultural contributions of four Aboriginal women artists, while her documentary *Today Is a Good Day: Remembering Chief Dan George* (1999) honored the tremendous impact of actor and activist Chief Dan George (Tsleil-Waututh), who opened many doors for Aboriginal actors and filmmakers.

Kainayssini Imanistaisiwa: The People Go On (2003) vividly illuminates Todd's unique film aesthetic, visual sensibility, and articulation of visual sovereignty. This experimental documentary explores the issue of repatriation within the Kainai Blood community of southern Alberta. It is an impressionistic film that lyrically evokes a sense of home, land, ancestors, and memory. The film opens with an honor song, a cultural protocol that Loretta Todd follows in all of her films. The film begins and ends with wide shots of the windswept open prairies that are home to the Kainai people (fig. 36). One example of how Todd makes use of the motion effects inherent in digital video is her innovative use of split screen for these wide shots of the prairie landscape, which creates a panoramic effect that envelops the viewer in the green rolling hills of the prairie and seemingly endless stretch of blue sky arching across Kainai territory. This is a striking documentary in many ways, not the least of which is its move away from conventional documentary aesthetics, structure, and framing to focus on the way in which objects are connected to memory, Kainai ancestors, the land, a sense of home, and the Kainai way of life.

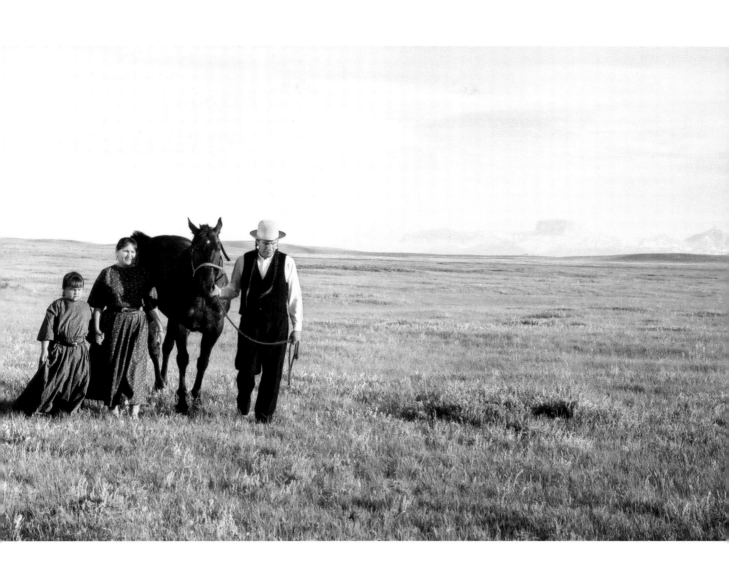

Fig. 36: Loretta Todd (Cree-Métis), still from *Kainayssini Imanistaisiwa: The People Go On*, 2003. Video, 70 min. © 2003 National Film Board of Canada. All rights reserved. Photo: Morton Molyneux

Todd blends sound, color, light, and language to convey a sense of Kainai cultural memory. During the scenes in which the objects are filmed inside glass museum cases, the Kainai language can be heard in soft whispers; it seems as if the ancestors who created these things are given voice on screen. Talking-head interviews are interspersed with extreme close-up shots of elders speaking about the importance of these objects and their place in Kainai cultural traditions. The interviews were also shot primarily outdoors, with the landscape as a backdrop, further reinforcing the connection between the Kainai people and their homeland.

Another innovative technique used by Todd to effectively make use of motion effects in *The People Go On* can be seen in the interludes between interviews. These are flag sequences during which white flags are filmed waving in the wind on the prairie at dusk, with archival photographs of ancestors' faces projected onto them. This haunting and powerful insertion of the ancestors, and the way their faces ripple and sway on the flags, makes a stronger impression on the viewer than if Todd had simply used archival photographs as static two-dimensional images. Through inventive on-screen aesthetics like this—interviewing people outside in the landscape, split screen, panoramic vistas, and inscribing the Kainai ancestral presence through the faces on the flags—Todd exploits the creative possibilities of motion to express visual sovereignty and to articulate a new vision for Aboriginal documentary practice.

Language in Aboriginal Mediascapes

Connections between language, land, and identity emerge in Kevin Burton's film *Nikamowin* (the title translates to "Song" in English). Burton is Swampy Cree and was raised on the God's Lake Narrows Reserve in northern Manitoba, where he grew up speaking Cree as his first language. He left his community as a teenager to attend high school in Winnipeg. He has spent much time in Vancouver and currently resides in Winnipeg, although he continues to maintain close ties with his reserve community, where the majority of his family still lives. He is a fluent Cree speaker who feels very strongly about the importance of maintaining Indigenous languages. In an interview he has said that his primary goal as a filmmaker is to create films in the Cree language for Cree and Indigenous audiences (Dowell 2013, 157).

The Cree language is a central component in Burton's work. All of his films—with one exception (*Writing the Land*)—are in Cree. *Nikamowin* emerged out of his experiences in Vancouver and the sense of isolation he felt not having any Cree speakers to talk with. He once recalled to me how profoundly disorienting this experience was for him. He remembered how he used to repeat Cree words to himself over and over just to keep his language in his mind and on his tongue. This film, which visually and aurally is quite unlike anything many viewers have seen, is, in Burton's words, "based on how I hear things as a Cree speaker. Those fundamental sounds that shape how I hear and view the world." Raw and altered Cree sounds form the primary soundtrack for the film, and Burton's traditional territory on God's Lake Narrows is a prominent feature in the film. Burton explained that he is absolutely committed to filming on his land, and it is this relationship to his traditional territory juxtaposed against images of the urban setting of Vancouver that forms the visual track of the film.

The film opens with scenes of a boat rocking back and forth on the water while the personified voice of the Cree language asks a young man whether he speaks Cree. The boat bounces up and down on the water, and the audio track begins a

repetition and layering of Cree words, sounds, and syllables. A continuous whooshing sound of deep breaths remains constant through the entire video, providing an underlying layer to the manipulation and distortion of Cree syllables. Color shifts in the visual track also amplify the strong bass and repetition of certain audio sounds, and the image "jumps" to bass beats as if in a hip-hop rhythm.

Experimenting with focus, the size of the visual track on screen, and the play of lines and space on the water, Burton seeks to visually replicate the audio track, which includes the voice repeating Cree sounds and the constant whooshing of breath. "Where are you from?" becomes a refrain throughout the film as the bright blue winter skies and long panning shots of woods covered in snow illuminate the beauty of Burton's Cree territory. When the voiceover asks, "Do you live there now?," the screen is filled with changing close-up shots of verdant lily pads filling a spring pond, marking a visual shift not only in seasons but also in the journey from God's Lake Narrows Reserve to Vancouver.

During this liminal space and journey between reserve and city, motion effects are used as the image speeds up and the size of the visual track gradually shrinks until all the viewer sees are train tracks leading into the city, as the many layers of audio effects and Cree syllables continue to repeat in a hip-hop rhythm. Gradually the landscape shifts from lush, green, forested mountains to concrete urban spaces, and the color scheme of the film shifts to a decidedly grayer palette, made all the more disorienting for the viewer by extreme motion effects speeding up the image and camera movements that shift the image out of focus. The volume increases and suddenly the viewer sees a black screen. A deep, distorted audio voice that sounds as if it is speaking through a megaphone adamantly asks, "Are you afraid?" and then commands, "Do not put down your language."

The dizzying use of motion effects in this film is especially prominent as the film rushes toward its powerful conclusion, and the images gradually widen and shrink both horizontally and vertically through split-screen cutouts while the music made from the repeated Cree syllables rapidly increases until the frantic closing sequence, where the voiceover asks, "What are you going to do to bring your language home?" The film then quickly moves from the space of the city back to the reserve landscape with wild camera movements, reverse motion, and a rapidly increased pace. The final sequence includes five horizontal split screens with various images from Burton's reserve landscape filling the top three bars on the screen, juxtaposed against the city shots from Vancouver and the trip back to Vancouver on the bottom two bars (fig. 37). The images now move at a frantic pace while trying to navigate between the space of the reserve and the city, evoking a sense of disorientation. In a reference to, and critique of, the detrimental impact of the residential school system on Aboriginal languages, the film closes on a black screen on which appears a quote from Secwepemc artist and activist Tania Willard: "You cut my tongue now only my heart speaks." The soft sound of the whooshing breaths fades in and out in the background.

This complex, multilayered film deconstructs the Cree language while speaking to the ways in which Aboriginal individuals navigate between traditional territory and urban space. Through his experimentation with split screen, audio distortions, and motion effects, Burton creates a uniquely visual and aural Cree media landscape that meditates on the connection between land, language, identity, and the implications of language loss for Aboriginal people and communities. This is most apparent when the voiceover, as a personification of the Cree language, insistently asks, "What are you going to

Fig. 37: Kevin Burton (Swampy Cree, born 1979), still from *Nikamowin*, 2007. Video, 11:15 min. Courtesy of Kevin Burton and Vtape.org © Kevin Burton

do to bring your language home?" and later orders, "Do not put down your language." The film was named one of Canada's top ten short films of 2008 by the Toronto International Film Festival (TIFF) and was acquired by the National Gallery of Canada.

Burton describes the way that the Cree sounds, through distortion and repetition, become a hip-hop remix as his experimentation with making language "cool" to a young audience. In a 2009 radio interview with IsumaTV, Burton explained, "I'm really adamant about keeping the language. I'm really adamant about talking with all the old people about it, and I'm really adamant about exploring how the language works. I'm an urbanized, tech-savvy individual living in 2009. What I'm exploring is how to bring traditional ways into contemporary ways and utilize them every day in order to create relationships with my peers and with my elders. And I thought this is how I need to make sense of that within my filmmaking" (IsumaTV 2009). When I asked Burton if his work has a particular Cree aesthetic, he replied affirmatively, citing the use of the Cree language and land in his film. He explained, "With *Nikamowin* I have a particular rhythm, and it's definitely based on how I hear things. *Nikamowin* is the most literal translation of that. The rhythm of how those syllables fall together is a translation of a Cree aesthetic. And visually my commitment to filming on my land absolutely creates a Cree aesthetic" (Dowell 2013, 164).

Conclusion: New Directions in Digital Interactive Media

I hope that my discussion of these three films gives the reader a sense of the range of Aboriginal media art as well as an understanding of some recurring themes: land, language, identity, and politics. The three filmmakers whose work I discuss here each have a unique, individual artistic vision, and yet that vision is deeply informed by strong ties to their respective Aboriginal nations. They, like other Aboriginal media artists, work to integrate Aboriginal languages, histories, and cultural protocol into the production and aesthetics of film, and through this process they express Aboriginal visual sovereignty.

Aboriginal media artists are also moving into the realm of interactive online digital media. I will touch on this only briefly to mention two innovative online websites that feature Aboriginal media art: *Beat Nation*, curated by Tania Willard and Skeena Reece (beatnation.org; fig. 38), and *God's Lake Narrows*, created by Kevin Burton with the Itwé Collective (godslake.nfb.ca; fig. 39).

Both these websites have connections to on-site exhibitions in artist-run centers. For example, *Beat Nation* was curated first as an online exhibit by Tania Willard and Skeena Reece for the grunt gallery and then held its first on-site installation at the Galerie SAW Gallery, Ottawa. *Beat Nation* was subsequently expanded in 2012 into a full exhibition co-curated by Tania Willard and Kathleen Ritter for the Vancouver Art Gallery, which traveled for three years to major Canadian arts institutions including the Kamloops Art Gallery; The Power Plant, Toronto; and the Musée d'art contemporain de Montréal. *God's Lake Narrows* began as an exhibition at Urban Shaman, Winnipeg, and then moved online in an interactive format with the National Film Board of Canada. *Beat Nation* provides an outlet for artwork and media art that examines hip-hop as integral to Aboriginal youth identity and the urban Aboriginal experience, while *God's Lake Narrows* provides a specific, localized look at "reserve reality" on Kevin Burton's home reserve. Both of these works confound and confront stereotypes that dominant Canadian society has about Aboriginal

Fig. 38: Screen shot from *Beat Nation* **showing still from Nicholas Galanin's film** *Tsu Heidei Shugaxtutaan part 1.* Tania Willard and Skeena Reece, curators; Archer Pechawis, web designer; grunt gallery, producer; Nicholas Galanin, featured artwork.

Fig. 39: Screen shot of *God's Lake Narrows* **website.** © 2014 National Film Board of Canada. All rights reserved.

people, and both of these websites articulate Aboriginal visual sovereignty in the virtual realm, as they invite viewers—Aboriginal and non-Aboriginal—to examine and explore Aboriginal cultural identity on Aboriginal terms and from Aboriginal perspectives. After thirteen years studying Aboriginal media in Canada, I eagerly anticipate seeing what new and inventive directions Aboriginal media artists will move in as they creatively reimagine media technology in the service of Aboriginal cultural traditions.

REFERENCES CITED

Bell, Lynne. 2010. "Dana Claxton: From a Whisper to a Scream." *Canadian Art* (winter 2010–11): 102–7.

Claxton, Dana. 2005. "Re:wind." In Townsend et al. 2005, 14-41.

Dowell, Kristin. 2013. *Sovereign Screens: Aboriginal Media on the Canadian West Coast*. Lincoln: University of Nebraska Press.

IsumaTV. 2009. "Kevin Burton, Cree Filmmaker"; http://www.isuma.tv/isumatv-interviews/kevin-burton-cree-filmmaker. Accessed November 20, 2015.

Loft, Steven, and Kerry Swanson, eds. 2014. *Coded Territories: Tracing Indigenous Pathways in New Media Art*. Calgary: University of Calgary Press.

O'Pray, Michael. 2003. *Avant-Garde Film: Forms, Themes, and Passions*. London: Wallflower Press.

Rickard, Jolene. 1995. "Sovereignty: A Line in the Sand." In *Strong Hearts: Native American Visions and Voices*. New York: Aperture, 51–61.

Stewart, Michelle, and Pamela Wilson, eds. 2008. *Global Indigenous Media: Cultures, Poetics, and Politics*. Durham: Duke University Press.

Townsend, Melanie, Dana Claxton, and Steven Loft, eds. 2005. *Transference, Tradition, Technology: Native New Media Exploring Visual and Digital Culture*. Banff, Alberta: Walter Phillips Gallery Editions.

Verrone, William. 2011. *Avant-Garde Feature Film: A Critical History*. Jefferson, NC: McFarland and Company.

Life as Motion, Motion as Life
Expressions in Filmmaking and New Media

Leena Minifie

In this essay I will consider the premise of Indigenous art in motion and, in particular, how new technology is being used to "move" this art forward. There is no question that this is happening, but we need Native art historical reference to put Native art, including digital and new media art, in its full and appropriate context. Work is constantly evolving and coming back to a place of wholeness where artists can blend all elements—such as visual art, dance, sound, and sculpture—with technology. New media and interactive art are very close to art created by our ancestors, which was always multidisciplinary, layered, relational, and complex.

My own work includes installation and interactive art as well as filmmaking. As a trained dancer and choreographer, movement greatly informs my practice and life philosophy. I am a member of the Gitxaala Nation and of Tsimshian descent on my mother's side and British descent (third-generation settler) on my father's side. My clan is Gispudwada (killer whale), and I am from the House of Wa'ta'lii. I was raised a few hours from my home territory in Kitimat, British Columbia (traditional territory of the Haisla Nation). I grew up in a small industrial company town located on the Douglas Channel, a two-hour drive from Alaska. In 2001, I graduated from the Motion Picture Program of Capilano College (now Capilano University). I also attended the Indigenous Media Arts Group (IMAG)

professional training program in Vancouver, where I was able to study under some of Canada's most influential Native media artists, such as Dana Claxton, Archer Pechawis, Loretta Todd, and Cease Wyss. In the IMAG program we studied the new media works of artists such as Rebecca Belmore, Lori Blondeau, Reonna Brass, Thirza Cuthand, James Luna, and Skawennati.

At this time I was also dancing with and being instructed by Michelle Olson, artistic director of Raven Spirit Dance. In cultures throughout the world, dance emerged from a need to celebrate life and living. In her book *The People Have Never Stopped Dancing: Native American Modern Dance Histories*, author Jacqueline Shea Murphy states: "All across the Americas, on the large and small stages of many sorts, the people have never stopped dancing, in multiple ever-expanding ways" (Murphy 2007, 264). Dance is a form of expression based on relationships to place, culture, and identity; it binds us to each other and to our spiritual selves. Dance is only one element of Indigenous arts and is usually combined with other elements of song, story, language, and lineage. In the history of Western art, dance is often a beautifully simple expression in and of itself that stands alone. In its very essence, dance is movement of the body through time and space. This movement unites us to place (or space) where we express a gratitude for life, and it connects us to our

ancestors throughout time. As a form of storytelling, it can honor lineage, showcase kin ties, and recount tribal histories.

Connected by Innate Rhythm

I made my first media art piece, a single-channel installation called *Connected by Innate Rhythm*, in 2002 (fig. 40). In it I attempted to address some of the same questions that Murphy, a professor in dance at University of California, Riverside, addressed in her book. The video art piece was originally projected on a four-foot drum replica to represent the inextricable connection between traditional and contemporary forms of dance and song practiced by Indigenous people, practices that will forever endure. I used an early form of digital video to showcase the evolution of movement of various Native dancers to explore how ancient traditional dances are related to the modern styles of expression that Indigenous people use to relate and create today. The work entailed a visual exploration of the history of Native dance, showing how both style and form differed across tribal nations in Canada. Eventually the video cuts to a performance of a contemporary Native modern dancer. Like the video sequence progression, dance itself is always evolving and transforming. The evolution, specifically of fancy dance, was also addressed by Murphy, who stated that "dance is constantly evolving in relation to changing times and contexts, requiring innovation, creativity, flexibility, endurance, and strength as well as pride in and connection to Indian identity" (Murphy 2007, 286n63).

Over time, Indigenous and tribal movements have combined with modern influences, but I don't believe that ultimately these appropriations affect the nature and essence of Indigenous dance. I laid out the video as a multilinear progression from 1960 until the present day, coastal dance groups to prairie dance styles, to emphasize the changes of movement style and the intersecting of cultures and the reasons for dancing. This included footage of the traditional Plains fancy dance intercut with archival footage and contemporary tribal dances from the West Coast. A major theme woven throughout the piece is the concept that drumbeats are heartbeats, via the images of heaving human chests projected on the surface of the drum, paired with the sound of breath, heartbeats, and traditional drumbeats. This comes at the beginning and end of the piece. It is a well-known concept and philosophy shared across many nations that the drumbeat represents the heartbeat. This visual pairing offers a reminder of the connection of rhythm, movement, our breath, and our rapidly beating heart that is achieved during dancing, where participants become interconnected with others, community, and creator through their movement in dance. The artwork is a visual reflection of the synergy of dance, music, and spirituality.

The video ends with breakdancing and hip-hop influenced beats. Here we can see how Native dance is still morphing as new forms of movement are being explored between cultures, and interchange occurs between traditional, pop, and modern influences. Beyond the dichotomy of modern/traditional, we see how Native culture has also been exchanged even between nations. Like dance, culture is always in a state of motion.

Connected by Innate Rhythm was among several works of mine that explored the hybridization of traditional Indigenous dance with contemporary forms. Hip hop has also been a very strong cultural influence. In fact, hip hop was the premise of the exhibition *Beat Nation: Art, Hip Hop and Aboriginal Culture*, which included my piece *Geeka* (*Water's Edge*), discussed later in this essay. The foreword of the publication that accompanied the exhibition stated:

> [The] prevalence of hip hop in Aboriginal communities should not be seen as a

radical break from the past, but a continuum. Aboriginal cultures on this continent have consistently adapted to new influences. This sense of innovation and transformation, based on trade, exchange and conflict with other cultures, continues today in contemporary Aboriginal experience and mainstream culture and weaves through many different elements of Aboriginal society (Ritter and Willard 2012, 9).

The main curator of *Beat Nation*, Tania Willard (Secwepemc), also noted the intercultural influence of urban hip hop on Native contemporary expression. In her own words, Willard explains: "Aboriginal artists have taken hip hop influences and indigenized them to fit Aboriginal experiences: The roots of hip hop are there, but they have been ghost-danced by young Native artists who use hip hop culture's artistic forms and combine them with Aboriginal story, experience and aesthetics" (beatnation.org).

Dance Critique for Indigenous Works

There are limits to using Western art history and critique for studying Native American art. Postmodern and contemporary theories are limited and inadequate for analyzing Native American contemporary dance because they are derived from an understanding of Western cultures, and dances are connected to the cultures from which they originate. Native dance finds its roots in Native histories, which are not purely aesthetic but a celebration of life and connection in this moving universe in which we exist.

In his book *Exhausting Dance: Performance and the Politics of Movement*, André Lepecki examines postmodern choreography. Lepecki considers the history of Western dance and observes that the aim of nineteenth-century classical ballet, which he refers to as Romantic ballet, "was to present dance as a continuous motion, a motion perfectly aimed upwards,

animating a body thriving lightly in the air" (Lepecki 2006, 3). As a fundamental postmodern inquiry into the deconstruction of movement, Lepecki focuses on concepts of continuous movement, or motility, versus stillness. The author describes how postmodern dance is concerned with the gradient of movements from frenzy to stillness. Lepecki addresses European modern dance forms and discourse and Western dance history and engages in a dialogue which, I believe, holds little to no relevance to contemporary Indigenous dance pieces due to stark ontological differences between the two forms.

So how do we begin to develop a dialogue for Native works in dance and motion? Lepecki maintains that "dance ontologically imbricates itself with, is isomorphic to, movement" (Lepecki 2006, 2). Where Lepecki discusses motility versus non-motility as postmodern exploration, Native contemporary dance, I feel, does not need to go to the extremes of limitation of movement or near-stillness to question the essence of movement or identify that even stillness is movement. These concepts cannot extend to the roots of Indigenous dances, whose forms precede the concept of continuous movement in ballet.

The deep-rooted ontology of "life as movement" and movement's connection to Indigenous ritual and spiritual culture extends as an anchor. It serves as a reminder of Indigenous practice, and it ties together the act of dance and the expression of gratitude for living. Pueblo and Spanish philosopher Viola F. Cordova illustrates a tribal perspective on movement and motion that predates Western dance history. This Native philosopher explains that movement is a universal quality present in all matter; there is no such thing as complete stillness in our universe. As she wrote in her book *How It Is: The Native American Philosophy of V. F. Cordova*, "If something exists, it is in motion and if there is motion there is life. Everything that exists is in motion. Therefore

Fig. 40: Leena Minifie (Gitxaala Tsimshian, born 1977), *Connected by Innate Rhythm*, 2002 (installation view). Single-channel digital video installation on drum replica
© Leena Minifie

everything that exists is alive" (Cordova 2007, 92). This worldview can be seen across Indigenous art and philosophy. Not only is everything moving, but everything is also alive. Indigenous peoples acknowledge plants and animals as sentient. All beings, even those that may look stationary, like rock and earth, are acknowledged to have agency in high-context tribal languages. In the grammar and syntax of the language of my Tsimshian people (Smalyg'ax), and my nation Gitxaala, for instance, everything is treated as alive, even when addressing what Westerners would identify as objects. Writers such as Vine Deloria Jr., Scott Momaday, and Leslie Marmon Silko have all addressed this concept of all things as sentient beings, using English to describe Indigenous ontology.

Furthermore, Western science has proven that even atoms continuously move at the subatomic level. From the philosophy of Plato ("Everything flows, nothing stands still") to English philosopher William Hazlitt ("Everything is in motion. Everything flows. Everything is vibrating"), the recognition of constant motion has been around. Philosophy and science share this perspective with Indigenous people. These views are congruent in that all matter in life is in constant motion. From both a Western and Indigenous philosophical perspective there would be no betrayal of dance through non-movement, as suggested by Lepecki. An exploration based solely upon stillness as an "absence of movement" in Indigenous dance would not come up because there is no absence of movement in life. Everything is constantly moving everywhere in the universe whether we can observe it or not. Whether we as human bodies stand still, or not.

Sense of Home

New media art can express the movement of life, the art of being alive, and the act of living in nature. Things like flowing water, shifting sand, growing plants, traveling animals, and the sounds that accompany these beings and their actions can be recorded, edited, and played back. Moving images can represent and reflect nature in all its activity: moving, growing, maturing, and dying. These processes, which are the cycle of life, can be captured and displayed in the digital realm.

My interactive new-media installation, *Sense of Home* (produced in collaboration with other video and sound artists and web designers), consists of eight videos on a computer hooked up to a multitouch monitor or touch-screen-capable device (storiesfirst.ca/SenseofHome). Each of the eight is like a slice of pie in a circular whole (fig. 41). Audio plays on adjacent speakers pointing toward the user. Any audience member can approach the kiosk and choose to play, or pause, the videos by touching the corresponding images.

In this work I aimed to create through visual rhythms and sound the presence of my home and home landscapes, as well as those of other people who will interact with this piece. I believe this work successfully reflects the visual environments and acoustic ecologies of the natural scenes portrayed.

I wanted the audience to determine the composition of the piece through the interactive touchscreen. Viewers were allowed to choose which video piece to play. Each video has a different-length soundtrack, which creates an original composition every time based on when it is started and how it combines with the other soundtracks. I purposely picked different sounds and images from different environments because "home" means different things to different beings. While I would have preferred to include all the ecological systems of

Fig. 41: Leena Minifie, *Sense of Home*, 2012. Interactive media installation. © Leena Minifie

North America, I opted for major markers, such as the desert, ocean, river, forest, and mountains. These films represent peoples' attachment to place and honor these landscapes as living, breathing entities with their own aesthetics and their own sounds.

Movement in an Indigenous Context

As previously mentioned, Western dance critique is limited for discussions of Indigenous dance and the histories of Indigenous contemporary dance, because these critiques and nomenclatures are based largely on Western dance forms, such as ballet and modern dance. This view only acknowledges "form" and ignores ritual or ceremony, which is central to all Indigenous dances.

To develop a Native-specific theory on dance or to engage in Native dance criticism, we must first consider Indigenous ontology. The purpose of Indigenous dance cannot be removed from its cultural context, even as it has evolved into contemporary forms today. Dance is one of the elements required for ceremony, like song, prayer (language), medicine, and offerings. The form of movement itself holds within it a practice that is ancient. When examining the curriculum for Native dance teachings, Kacy Crabtree expresses that "a study of Native American art forms, specifically dance, provides insight into the history, lifestyle, religion, ceremonies, recreation, and traditions of the people and how they relate to present-day environments" (Crabtree 2009, 13). Movement came from an interaction with Indigenous peoples' environment. Crabtree emphasizes that dance relates to the present-day environment surrounding us; however, the relationship extends beyond it. Dance, across all tribal nations, is ontologically crucial to ceremony and ritual at all levels. It was and still is used for interacting with nature, making offerings, and harmonizing our relationship with Mother Nature,

among many other purposes. We cannot extract this ceremonial history from contemporary Indigenous dance even though a secular performance practice exists today. Indigenous peoples' philosophies not only relate to the environment through dance, but how the environment is affected by dance, because according to this worldview, dance affects the environment.

To combine dance with film is a natural way to showcase movement-based arts. Passages of the human body through space also allow us to travel through time and across geographies. Movement is constant change occurring within us and around us. Our bodies, our cultures, our languages, and our philosophies are all in constant motion. They interact and collide with other ideas, concepts, and other cultures.

In my 2005 dance film *Geeka* (*Water's Edge*), I addressed water issues by juxtaposing the environments of desert and sand, fluidity and rigidity, in the choreography itself (fig. 42). *Geeka* (*Water's Edge*) is a narrative, modern Native dance film that explores one Native American dancer as she interacts with a future in which the most powerful rivers and pristine lakes run dry. It stars Melina Laboucan-Massimo (Cree), and I produced and directed it through the Dance for the Camera intensive summer program on Vancouver Island. The film is an exploration of activism through dance in the environment. In it I relate to the practice of interacting with my surroundings and my belief in the power of dance and where dance originates from within my own nation. This has been a main reason that has brought me to the creation of films and new media pieces about land and our relationship to land and environment.

Although contemporary forms of dance are hybridized with traditional forms in Indigenous dance today, we cannot ignore the cultural roots and purpose. In all of these core expressions, movement was one of the ways to honor having an existence

Fig. 42: Leena Minifie, still from *Geeka (Water's Edge)*, 2005. Single-channel video, 6:46 min. © Leena Minifie

in this world—to give thanks for the fact that we are able to move, to breathe, and to be alive. I often recall a particularly influential Aboriginal Day celebration. During the celebration, a young men's fancy and chicken dancer, Theodore Bison, explained the practice of dancing to the youth present. In the middle of his presentation he stated: "We dance because we can. We dance for those who cannot dance: the elders, the disabled, the babies." For me, this explained the privilege and responsibility of dancing and being dancers in Native and tribal cultures. Like Theodore Bison, I move because I am able. Dance provides me with a foundation that reminds me of who I am and where I fit in the world. I have been placed in this body. Moving this body is an acknowledgment of life. My work shares what it is like to be at home in my body; moving to rhythms keeps me grounded and connects me to my environment.

Movement and sound form a vital marriage that impacts how we perceive and connect to our place, all natural elements, and other people. They also tie us to a time and place. In this respect, I must share that I have also been heavily influenced by electronic music, which I was exposed to as a youth. I believe the complexity of modern composition, like electronic music with its samples and multiple layers and textures, is complex in the way that nature is complex. The premise of electronic music is sampling: you sample from influences and the environment. You play with layering things.

My work acknowledges my attachment and interconnectedness to land, place, family, and myself. It also emphasizes the great responsibility we, as individual beings, have to these connections. The interactive elements I have discussed embody an art that is true to the multidisciplinary nature of traditional Native works. Other contemporary Native artists, such as Jason Baerg, Kevin Lee Burton, Dana Claxton, Beth Dillon, Cheryl L'Hirondelle, Steven Loft, Ahasiw Maskegon-Iskwew, Archer Pechawis, Postcommodity collective, Skawennati, Cease Wyss, and Lawrence Paul Yuxweluptun have also linked Indigenous cultures with interactive technology and new media works. The works of A Tribe Called Red, Jackson 2Bears, and Skookum Sound System have also paired contemporary live electronic music with live visuals.

Interactive media have the ability to layer song, movement, and language to create an environment in ways that are close to the complex forms of artistic expression that Natives have used in the past and continue to use in the present. As Greg Younging notes, "intelligent and carefully proposed multimedia projects can bring ancient traditions and cultural practices into the technological age uncompromised and with cultural significance" (Younging 2005, 186). Furthermore, it can also bring relationships and connectivity to audiences and build community by encouraging dialogue between different cultures. If this connectivity is continually advanced in new media art, then this connectedness can be extended to audience members—Native or non-Native.

As we delve deeper into technology and advance our uses of multimedia, we are able to access the main elements that were always present in cultural expression and Indigenous philosophies. As technology evolves we are able to get closer to the days where dance, song, visual art, and language were interwoven and inseparable from one another. While technology could never replace them, it may very well bring us back to the multidimensional works Indigenous people have always created, and which Western art has overlooked in our histories and in our present forms of art today. The use of movement and interactivity in our expression can therefore be regarded as an extension of our realities—and a way to share them.

NOTES

I want to recognize that my original presentation took place on Indigenous land at the Denver Art Museum and give acknowledgment to the Southern Ute territories. I also want to thank John Lukavic and everyone at the Denver Art Museum for organizing this symposium. I wish to extend my gratitude to Kristin Dowell, who has supported and guided me since the beginning of my work and who recommended me for this program. I finally want to thank my instructors at the Institute of American Indian Arts, collaborators, friends, family, and my Nation (Gitxaala) for their continuous support. I would not have been able to create my art without this support.

REFERENCES CITED

Cordova, Viola F. 2007. *How It Is: The Native American Philosophy of V. F. Cordova*, ed. Kathleen D. Moore et al. Tucson: University of Arizona Press.

Crabtree, Kacy E. 2009. "Introduction: Dance Offers a Window on Native American Culture, Past and Present." *Journal of Physical Education, Recreation, and Dance* 80, no. 6 (2009): 13–14; 300.

Lepecki, André. 2006. *Exhausting Dance: Performance and the Politics of Movement*. New York: Routledge.

Murphy, Jacqueline Shea. 2007. *The People Have Never Stopped Dancing: Native American Modern Dance Histories*. Minneapolis: University of Minnesota Press.

Ritter, Kathleen, and Tania Willard. 2012. *Beat Nation: Art, Hip Hop and Aboriginal Culture*. Vancouver: Vancouver Art Gallery.

Younging, Greg. 2005. "The Indigenous Tradition/New Technology Interface." In Melanie A. Townsend et al., *Transference, Tradition, Technology: Native New Media Exploring Visual and Digital Culture*. Banff: Walter Phillips Gallery Editions.

Peyote Arts in Motion
Religious Diffusion, Artistic Change, and Museum Collections

Daniel C. Swan

The modern form of the Peyote Religion coalesced on the reservations of southwestern Indian Territory in the late 1870s and quickly gained converts in neighboring reservation communities. By 1900 the majority of tribes in the territory had members who practiced the Peyote Religion, and at the time of Oklahoma statehood in 1906, Peyotists comprised a strong majority in many communities. Chartered in Oklahoma in 1918 as the Native American Church, the Peyote Religion subsequently spread into the Southwest, Great Basin, and Northern Plains regions. The movement of Peyotism into Canada in the 1930s made the Native American Church an international religion. Today the Church assumes an important role in the lives of hundreds of thousands of native people in Canada, the United States, and Mexico.[1] A vibrant expressive culture, made up of traditional, folk, and fine arts; complex musical repertoires; and diverse ritual performances has developed in association with the Peyote Religion. Throughout the twentieth century, Peyote arts were responsible for the continuation of traditional styles and techniques and also fostered the development of innovative approaches and contemporary styles.

Looking back on this history from the early twenty-first century, I argue that the Peyote Religion has inspired one of the most enduring and widespread genres of contemporary Native American art. This essay draws on twenty years of research on the artistic traditions associated with the Native American Church and extensive interaction with the people who create and use the items, objects, and works that comprise Peyote arts.

I believe that Peyote arts exemplify the concept of motion as it relates to Native American traditional arts. Peyote arts follow wherever the religion is practiced, as new members work to accumulate the ritual instruments and personal accouterments used by Peyotists. The Plains-style tipi, as the iconic place of worship for the Peyote religion regardless of the traditional house forms and ceremonial structures of any given community, epitomizes the adoption of a core set of material attributes in conjunction with the diffusion of the religion (fig. 43).

In this essay I discuss the circulation of Peyote arts within and between native communities and explore the impact of commercially available works on the growth of museum collections. I also contend that at certain points in the development of Peyotism, the rapid growth of the religion fostered periods of intensified commercialization with respect to certain artistic forms associated with the practice of the religion. These are situations in which the demand for ritual instruments and other material attributes of Peyotism exceeds the capacities of local artisans and kin-based exchange systems to supply them.

Fig. 43: Tom Fields (Muskogee Creek and Cherokee, b. 1951), Veterans "Meeting." Arthur Cox Marine Corps birthday meeting tipi, Fairfax, OK, 1996. Silver gelatin print. © Tom Fields

The distinction between Native American art created for use within a community and works created for consumption outside the locality in which they are produced is important in the discussion of Peyote art. The majority of the material culture associated with the practice of Peyotism is produced by members of the religion and then circulated through biological and social kinship networks. Many participants in the Peyote Religion create staffs, fans, rattles, drumsticks, jewelry, and other objects for themselves and other members of the church.

Dennis Lessard (1984, 24–27) and Dennis Wiedman (1985, 38–45) have noted that there is often a major distinction with respect to the quality and quantity of Peyote artworks produced for community consumption and those made for commercial exchange. While my experiences lead me to generally agree with their statements, I believe that the circulation of Peyote arts through market exchange is a more complicated equation when

considered over expanded temporal and geographic contexts.

My approach in this essay is influenced by the work of a number of scholars working to understand the processes that impact and influence the production and circulation of contemporary Indigenous arts. James Clifford aptly describes the intersection of markets, museum collections, and modern Indigenous cultural production on the Northwest Coast:

> Indigenous art (carving, building, painting, printmaking, jewelry and blanket design), work participating simultaneously in market and museum networks and in tribal ceremonial and political contexts, is a leading public manifestation of cultural vitality (Clifford 1991, 214–15).

I would suggest that in addition to functioning as a metric of cultural vitality, a community's artistic production is also a source of tremendous energy and dynamism that inspires social discourse, intellectual inquiry, and community action. As artists and their works circulate in various contexts, they negotiate complex sets of social relationships, multiple modes of production, and often contradictory patterns of consumption.

Tressa Berman (2003, 31–32) developed the concept of "ceremonial relations of production" to analyze the manners in which kin-based and capitalist economic forces interact in artistic production among women on the Fort Berthold Reservation in Montana. Berman contends that the introduction of cash economies on the reservation has provided new avenues for resistance and cultural continuity, often characterized by intensified ceremonial activity and new forms of cultural production (Berman 2003, 52–54). Also important to the current discussion is the ability of objects to navigate multiple regimes of value, moving from commodity status

to inalienable possession, only to arrive back in the marketplace imbued with cultural biography and enhanced economic value (Myers 2001, 8–10). In her comments during the planning for the School for Advanced Research (SAR) Advanced Seminar "Material Culture: Habitats and Values," Annette Weiner emphasized the importance of investigating the processes through which individuals and groups create value in objects and then employ those values in the construction of personal and collective identities (Myers 2001, 9).

Many of the objects that I address in this essay undergo a transformation when they are put into ritual action: when they are incorporated into religious services and used to pray for divine intervention or a miraculous cure, or in acts of thanksgiving, attrition, and confession. Feathers and fans become instruments for the transference of sacred properties and the conveyors of blessings, and rattles and drumsticks assume their role as musical instruments to accompany the voices of the singers as they present prayers in the form of Peyote songs. Given that the majority of the contemporary works that are the focus of my work were never consecrated through ceremonial use, I do not address the movement of these objects in ritual contexts. Ethnographic accounts of the religious ceremony of Peyotism abound in the anthropological literature, and numerous postings to photo, audio, and video sharing sites on the Internet provide ample opportunities to experience the performance of Peyote songs.

Moving Peyote Arts into Museum Collections

Museum collections constitute one of the best-documented records of religious art in native North America, not only in number but also in the extent of geographical and cultural diversity. Peyote arts are well represented in the collections of America's museums but are virtually unknown in museums

outside the United States. They have never been of great interest to most private collectors, based on their largely twentieth-century provenance. Peyote-related materials have often been regarded as less "authentic" than the material culture of previous religions, stemming largely from the various levels of Christian syncretism found in Peyotism and its material culture. This pattern may well have limited the amount of Peyote materials donated to museum collections relative to other genres and forms. It is my contention that museum collections of Peyote-related materials are largely the product of systematic collecting by field ethnologists and museum curators and thus differ significantly in quantity, quality, and provenance from other Native American traditional art forms in the twentieth century.

The earliest museum collections of the material culture of the Peyote Religion are located in the great natural history museums of the United States, including the National Museum of Natural History in Washington, D.C. (fig. 44), which James Mooney began collecting for in the 1890s; the American Museum of Natural History in New York, which benefited from early efforts by Alfred Kroeber and Mark Harrington (fig. 45–46); and the Field Museum of Natural History in Chicago. Other American museums with noteworthy collections of Peyote arts include the Denver Art Museum, thanks to the work of curators Frederic Douglas and Norman Feder and field ethnologist Alice Marriott (figs. 47–48), and the Milwaukee Public Museum, where Alanson Skinner and Nancy Oestreich Lurie

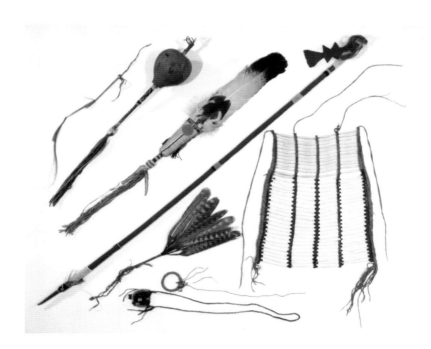

Fig. 44: Unknown Kiowa artists, Peyote instruments. *Left–right:* Hair ornament, gourd rattle, eagle feather fan, staff, hawk feather fan, pouch, beaded hair ornament, breast plate. Collected by James Mooney, 1891, on the Kiowa-Comanche-Apache Reservation, Indian Territory. National Museum of Natural History (#E152842) Department of Anthropology, Smithsonian Institution.

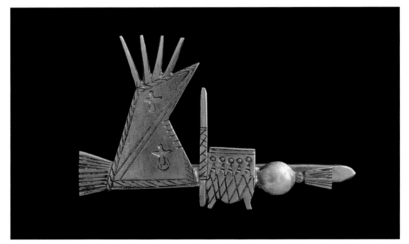

Fig. 45 (upper left): Unknown Kiowa artist, Neckerchief slide, date not known. Silver, 2½ x 1¾ in.
(6.35 x 4.45 cm). Collected by Alfred Kroeber, about 1894, Cheyenne and Arapaho Reservation, Indian Territory.
American Museum of Natural History 50.1/8393. Courtesy of the Division of Anthropology, American Museum
of Natural History.

Fig. 46 (upper right): Unknown Comanche artist, Eagle feather Peyote fan, about 1880. Golden eagle feathers, hide,
wood, silk ribbon, glass beads, pigments, 27 x 5¾ in. (68.6 x 14.6 cm). Collected by Mark Harrington in Oklahoma,
about 1909. National Museum of the American Indian, Smithsonian Institution (2/1617). Photo by Walter Larrimore,
courtesy of the National Museum of the American Indian.

Fig. 47 (left): Tom Little Chief (Kiowa, 1904–1979) Barrel-style fan, date not known, Anadarko, OK. Beads,
magpie feathers and macaw feathers, 26⅜ long x 1⅞ in. diameter (66.99 x 4.76 cm). Purchased by Frederic
Douglas from Jake Tingley about 1945, in Anadarko. Denver Art Museum: Native arts acquisitions funds, 1941.43.

Fig. 48 (above): Unknown Kiowa artist, Tie clip, date not known. German silver, 2⅜ x 1½ in. (6.03 x 3.81
cm). Purchased by Alice Marriott from Jake Tingley about 1938, in Anadarko, OK. Denver Art Museum: Native arts
acquisition funds, 1942.141.

added important objects and the acquisition of the James Howard collection in 1985 greatly enhanced the collection (figs. 49–50). Another important repository of Peyote arts is the Southern Plains Indian Museum in Anadarko, Oklahoma, founded in 1947 and operated by the U.S. Department of the Interior Indian Arts and Crafts Board, which in addition to collecting objects has fostered an exhibition and sales program for native artists. A new gallery dedicated in 2001 to honor longtime curator Rosemary Ellison provides a venue for rotating shows from community artists and the museum's permanent collection (fig. 51).

Peyote arts represent a genre of twentieth-century art that has traveled and settled in all sectors of the continent, wherever the religion has been adopted. In each setting, a core set of Peyote arts have been adapted to local preferences and standards to provide the means for the continuation of traditional forms and the opportunity to devise newly inspired works. As mentioned, these objects also made their way into museum collections—where they encountered value systems and interpretive orientations quite different from those of the individuals who ultimately use similar objects in their practice of the Peyote Religion.

Prominent among the themes that quickly become apparent in examining the documentation behind Peyote art collections is the role of purchase in the collecting process. Throughout the history of the Peyote Religion, new members of the Native American Church have been anxious to acquire a full set of "instruments" to create a personal "kit" that contains the minimum objects necessary to be a full participant in the ceremony. Personal peyote boxes typically contain a feather fan, a gourd rattle, and a drumstick. Various accessories and accouterments are also desirable, including a blanket or shawl, Peyote jewelry, and other personal items including handkerchiefs, combs, note pads, and pens. All of these

Fig. 49 (top): Unknown Ioway artist, Peyote fan and rattle, dates not known. *Fan:* Feathers, glass beads, cotton cloth, and brass studs, 14 in. (35.56 cm) long. *Rattle:* Gourd, wood, leather, glass beads, and horsehair, 15 in. (38 cm) long. Both collected by Alanson Skinner about 1922. Milwaukee Public Museum 30593/7322, 30594/7322. Courtesy Milwaukee Public Museum.

Fig. 50 (above): Julius Ceasar (Pawnee, 1911–1981), Cup, date not known. German silver, height 2 ⅝ in. x 2 ⅜ in. diameter (6.67 x 6.03 cm). Collected in 1958 by James Howard in Clinton, OK. Milwaukee Public Museum 65005. Courtesy Milwaukee Public Museum.

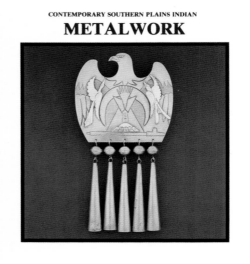

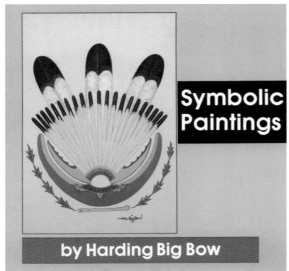

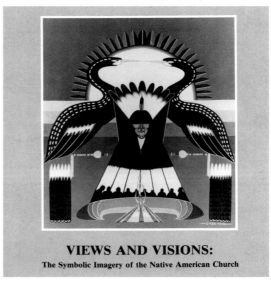

Fig. 51: Peyote arts exhibition brochures and publications, Southern Plains Indian Museum, about 1974–90. Anadarko, OK. Courtesy of U.S. Department of the Interior, Indian Arts and Crafts Board.

objects are often stored or transported in a cedar box, either handmade or commercially made (Swan 1999, 49; Swan 2010, 157–58).

There are several ways that new members of the religion obtain these objects. Ritual instruments and accessories can be received either singularly or in a group in the form of a gift, or Peyotists can construct these objects themselves.[2] Peyote instruments and accessories might also be gotten through trade with other artists who specialize in certain forms, and finally, they might be purchased in retail establishments that are often part trading post, art gallery, tourist outlet, and pawn shop. In Oklahoma and elsewhere, these institutions are generically referred to as "Indian stores."

The history of the commercial market for Native American arts in Oklahoma is poorly documented, and it is far beyond my ability or intent to address in this essay. The current situation of near non-existence of commercially available Peyote arts in Oklahoma belies the flourishing and vibrant market, which involved dozens of artists and numerous commercial outlets, that existed for Peyote-related arts in Oklahoma from the 1940s into the 1970s. Noteworthy were Tingley's Indian Store, McKee's Indian Store, E. M. Roberts, and the Southern Plains Museum gift shop in Anadarko; Nellie's Mohawk Indian Store in Clinton; the Redman Store in Pawhuska; Lyons Indian Store in Tulsa; Supernaw's Oklahoma Indian Supply in Skiatook; and Ozark Indian Store in Oklahoma City.[3] These stores, in conjunction with numerous other retail outlets, pawnshops, and galleries, carried sizable inventories of ritual instruments, shawls, blankets, jewelry, and other accouterments and accessories used by members of the Native American Church. Many of these stores advertised Native American Church supplies and materials in the major Indian hobbyist magazines of the period and in local powwow programs (fig. 52). The primary audiences for Peyote arts at these operations were Native American community members; separate

Fig. 52: Print advertisements for Peyote-related objects and materials. *Above*, McKee's Indian Store, 1971; *right*, Mrs. E . M. Roberts, 1962. Courtesy of Jim Cooley.

product lines were often available for tourists. My review of the acquisition records of these and additional institutions would suggest that an amazing quantity of the Peyote arts in public museum collections were at one time connected to Jake Tingley.[4]

Symbols of Faith and Belief Exhibition Initiative

In 1994, Gilcrease Museum was approached by Harding Big Bow, a Kiowa Roadman (main ceremonial official), past president of the Native American Church of Oklahoma, and a talented artist, regarding an exhibition focused on artistic traditions associated with the Church (fig. 53). Big Bow and other community members believed that diverse methods should be employed to educate both Native American and non-native audiences on the history of the Peyote religion in the face of increased federal restrictions on their religious rights and pursuits (see Smith and Snake 1996, Slotkin 1956, and Stewart 1990 for the legal history of Peyotism and its formal Native American Church organizations).

Following a series of consultations with peer institutions to explore potential loans and venues, and continued dialogue with a broader community of Peyotists, the museum undertook planning and initial development of the exhibition. As senior curator at Gilcrease, I served as co-curator with Big Bow and worked with a core group of advisors to develop the object list and interpretive outline for the exhibition (Swan and Big Bow 1995).[5] This collaboration culminated with the opening of *Symbols of Faith and Belief: Art of the Native American Church* at the Gilcrease Museum in 1999. The exhibition traveled to the Minneapolis Institute of Art; the Sam Noble Oklahoma Museum of Natural History at the University of Oklahoma, Norman; and the Navajo Nation Museum in Window Rock, Arizona.

Fig. 53: Harding Big Bow, Mountain View, OK, about 1990. Courtesy of Pearl Big Bow.

The collections of the Gilcrease Museum contained numerous examples of the traditional arts employed to create Peyote fans, rattles, drumsticks, and other religious instruments as well as an array of Peyote-themed fine artworks by numerous artists (Swan 2003). These materials provided the foundation for *Symbols of Faith and Belief*. Collections research indicated that the Peyote art collection at Gilcrease was assembled through sporadic collecting episodes between 1943 and 1963. In the late 1940s the museum became a patron of Native American artists including Fred Beaver, Acee Blue Eagle, Woody Crumbo, Solomon McCombs, Willard Stone, and many others, whom the museum supported through commissions, employment, and residency programs (Jones 1995, 12–14). The works of Blue Eagle, Crumbo, and Stone often incorporated themes and elements from the Native American

Church, and I believe these artists, particularly Crumbo, influenced Thomas Gilcrease's efforts to collect native arts executed in traditional media during the 1940–60s (Milsten 1991, 276–79), including ritual instruments and personal accouterments used by Peyotists (Swan 1998).

Gilcrease Museum significantly enhanced and expanded its holdings of Peyote arts when it acquired the Jim Cooley collection in 1995. Cooley built the collection between 1965 and 1995, largely in Oklahoma but also in New Mexico and Wisconsin. Among the few private collectors with an interest in Peyote arts, Cooley obtained both historic and contemporary works from a variety of commercial outlets. Thus the collections of Gilcrease Museum provided a great range of traditional and fine arts on which to base the exhibition, with particular strengths in Southern Plains easel painting and the traditional arts needed to create the ritual instruments and accessories used by members of the Church. The exhibition then borrowed from the collections of the American Museum of Natural History, Denver Art Museum, Field Museum, Milwaukee Public Museum, Museum of the Great Plains, National Museum of Natural History, and the Southern Plains Indian Museum and Crafts Center to complete the *Symbols of Faith and Belief* exhibition.

At each exhibition venue, we worked in advance with local chapters of the Native American Church to understand community preferences regarding the display of ritual instruments in their home territories and to gain access to contemporary artists working in Peyote traditions and forms. We wanted to include local artists and to build the contemporary Peyote art collections at Gilcrease Museum by acquiring their work.[6] This effort originated in Oklahoma, where a number of works were commissioned to provide contemporary works to include in the

exhibition (fig. 54). Nowhere was this acquisitions initiative more successful than in the Navajo Nation, where it led to the development of a comprehensive collection of contemporary Navajo Peyote arts that was displayed in the exhibition when it was at the Navajo Nation Museum in 2003 (fig. 55). I quickly realized that the production and circulation of Peyote arts both within and beyond the Navajo Nation provided a range of opportunities to explore

Fig. 54 *left:* **Gourd rattles. Richard Aitson (Kiowa, b. 1953), about 1997.** Wood, gourd, glass, horsehair, leather, feathers, beads, thread. Length: 23¾ in. (60.33 cm), diameter (of gourd): 3 in. (7.62 cm). Gilcrease Museum 84.2908. *Right:* **Philip "Joe Fish" Dupoint (Kiowa, b. 1954), about 1999.** Gourd, glass, wood, leather, feathers, seed, metal, length: 23 in (58.42 cm). Gilcrease Museum 84.2989. Both purchased by Daniel C. Swan in Tulsa, OK.

Fig. 55: Contemporary Navajo Peyote arts exhibited in *Symbols of Faith and Belief* exhibition. *Top left*, Rita Gilmore (b. about 1975), textile. *Top right*, M. Thompson (dates unknown), water bucket. *Above, left–right*, Raye Johnson (b.1952), pin; Zearl Begay (b. 1955), pin; Patrick Scott (b. 1966), fan; Patrick Scott (b. 1966), fan. From the collection of the Gilcrease Museum, Tulsa, OK.

the relationship between kin-based and market exchange in both informal and capitalist economic spheres. In many ways the situation that I encountered in the Navajo Nation provided the opportunity to witness the processes I infer for the commercial trade of Peyote arts in Anadarko, Oklahoma, in the mid-twentieth century (fig. 56).

Membership in the formal organizations of the Native American Church is always difficult to estimate with any precision. The 2010 U.S. Census reported a population of 332,000 for the Navajo Nation (Norris et al. 2010, 17), with a median age in 2008 of twenty-four years (Diné Development Corporation 2008).

In 1993, David Clark, then president of the Azeé Bee Nahagha of Diné Nation (formerly the Native American Church of Navajoland) suggested that 60 percent of Navajo adults are Peyotists (Moore 2003, 68). Assuming that the percentage has continued to increase, it is reasonable to suggest that there may now be in excess of 100,000 adult members of the Native American Church in the Navajo Nation. The scale of this focused population creates an intensive context for the efforts of informal and formal market exchange systems to satisfy the demand for artistic works generated by an expanding Church membership.

Fig. 56: Billboard promoting Peyote arts for sale at Cool Runnings Indian store, St. Michaels, AZ, 1995. Photo by Daniel C. Swan.

In a previous paper (Swan 2008), I presented a preliminary discussion of contemporary Navajo Peyote arts. My review of selected works led me to contend that the Navajo have developed a particularly rich adaptation of the diverse artistic media and techniques that accompanied their adoption of the Peyote Religion. The proliferation of Peyote artists and their respective works is reinforced by cultural constructs that tend to promote and inspire creative enterprise as a responsibility of every Navajo citizen.[7] What I find most exciting is the tremendous innovation that Navajo artists have brought to this important genre of Native American art. The energy and creativity exhibited in contemporary Navajo Peyote arts are a testament to Navajo ingenuity and the tremendous growth of Navajo Peyotism over the past three decades. It is within this aesthetic richness that I have attempted to document both internal (community) and external (market) forces that have helped to shape the production and circulation of Navajo Peyote arts.

Lessard (1984) and Wiedman (1985) have demonstrated that on the Northern and Southern Plains in the 1980s, there were very few if any works in the Peyote genre available in commercial markets, and those that did make their way to the marketplace were generally of inferior quality and did not meet minimum local standards. This remains somewhat true on the Navajo Nation; the highest quality works are largely restricted to kinship networks of circulation and are rarely available through commercial outlets (fig. 57). Among the Navajo, however, I have documented intermediate levels that expand this dichotomy to include a broader index of works that are primarily created for purchase by members of the Navajo community. As such they meet, and often exceed, minimum community standards with respect to quality of design and technical execution. The upper levels of the commercial market for

Fig. 57: Adrian Yazzie (Navajo, b. 1981), Cedar bag, 2012, Tuba City, AZ. Wool, taffeta ribbon, plastic beads, 24 x 9 x 1 in. (60.96 x 22.86 x 2.54 cm). Purchased by Daniel C. Swan in Tuba City, 2003. Sam Noble Oklahoma Museum of Natural History, the University of Oklahoma, 2013.3.11.

Navajo Peyote arts are among the best available through any means or mechanism.

Pins made by Hemerson Brown epitomize Navajo jewelry produced in the Peyote genre (fig. 58). They are executed in the preferred medium of sterling silver as opposed to the nickel (German) silver of the Plains tradition. They also incorporate traditional Navajo styles of concha design and a unique interpretation of the revered Peyote bird (*Anhinga anhinga*) depicted in profile.

Moving Peyote Arts into the Navajo Nation

My collecting activity has also documented instances in which products from external, native, and non-native sources have been introduced as successful commodities in the larger market for Peyote-related arts and products among the Navajo. Zuni artists have produced numerous pieces, largely pins and other jewelry, in the traditional Zuni medium of stone inlay that incorporate Peyote themes and designs (fig. 59). Because there is no historic or

Fig. 58: Hemerson Brown (Navajo, b. 1964), Peyote pins, 2003, Bread Springs, NM. Sterling silver, brass, coral, and faceted glass. Dimensions, *left–right*, 4¼ x 1¼ x ⅓ in. (10.79 x 3.17 x .85 cm), 4⅜ x 2⅛ x ½ in. (11.11 x 5.39 x 1.27 cm), 5⅝ x 3 in. (14.28 x 7.62 cm). Purchased by Daniel C. Swan in Gallup, NM, 2003. From the collection of the Gilcrease Museum, Tulsa, OK (L–R) 69.186, 182, 181.

ethnographic record of the institutional establishment of Peyotism at Zuni Pueblo, it is only logical that these pieces were intended for the neighboring Navajo community. This is an important example of a non-Peyote-practicing community producing objects for a neighboring community of ardent Peyotists who are eager to acquire the most inspired works available. Continued collecting in the Navajo Nation led me to a pin executed in the Zuni style but produced instead by a Navajo smith and sold in large numbers at the Gallup Flea Market to an audience desirous of Peyote jewelry produced in the Zuni style (fig. 60). This is a clear example of adaptation and reversal in the production and circulation of traditional arts between and within native communities based on demand and supply.

In 1997, again at the Gallup Flea Market, I purchased a carrying case for the metal (mostly cast iron) kettles used for the water drum, the central musical instrument in the Peyote religion. The case was constructed in Guatemala from ballistic nylon with an embroidered, generic Mesoamerican design motif as decorative accent. An additional example of non-native objects in the market for Peyote arts on the Navajo Nation is a set of etched, lidded glass bowls that I purchased in 2000 in St. Michaels, Arizona (fig. 61). These commercially produced bowls were mechanically etched in Phoenix based on a set of designs conceived by a native artist (Eddie Weber, personal communication, 2000).

My efforts to collect Peyote arts on behalf of the Gilcrease Museum and the Sam Noble Museum have benefited tremendously from the commercial outlets and market exchange discussed in this paper. The quantity, quality, and diversity of contemporary Navajo Peyote arts available commercially in galleries, flea markets, museum gift shops, and fairs within and adjacent to the Navajo Nation have been critical factors in my collecting activities, and I would not have had similar success if these materials were instead field-collected. Much of this collecting activity was focused in Gallup, New Mexico, the commercial epicenter for Navajo Peyote arts.[8]

To better understand the personal, social, and economic contexts in which these works are created and circulated, I have worked over the past fifteen years to develop personal and professional relationships with gallery owners and employees, visual artists, music producers, recording artists, and native consumers. I have collected artist biographies, observed the production and marketing of Peyote arts, and interviewed both native and non-native consumers. This approach has led to many enduring relationships in an ever-expanding network of visual artists, collectors, and dealers of Peyote arts from the Navajo Nation.

Discussion and Conclusion

The demand for Peyote-related works in and around the Navajo Nation has obviously exceeded the capacities of localized, kin-based systems of production and circulation. I have previously suggested (Swan 2008) that demographic scale and traditional philosophy are critical factors in the rapid expansion of the quantity, quality, and diversity of Navajo Peyote arts. Driving this situation are the large numbers of new members of the religion who are anxious to acquire the core set of objects necessary to fully participate in religious services. Navajo Peyotism has grown tremendously over the past thirty years, in tandem with increases in the overall Navajo population. The development of a robust commercial trade in Peyote arts is consistent with the long-standing tendency to purchase finished ceremonial objects among Navajo Peyotists (Aberle 1982, 170–72; Frisbie 1987, 440–41). Counter to prevailing patricentric patterns in Plains Peyotism, the matrilineal orientation of the Navajo supports a more gender-neutral pattern

Fig. 59: Unknown Zuni artist, Peyote pins, about 1960. Sterling silver inlaid with turquoise, jet, shell, and coral. *Left*, 3½ x ½ x ⅝ in. (8.89 x 1.27 x 1.59 cm); *Right*, 3⅞ x ½ x ¾ in. (9.84 x 1.27 x 1.91 cm). Purchased by Daniel C. Swan in Santa Fe, NM, 2011. Sam Noble Oklahoma Museum of Natural History, the University of Oklahoma, 2011.4.3–4.

Fig. 60: Johnny Mike (Navajo, b. about 1950), Peyote pin, 2009. Sterling silver, shell, turquoise, and coral, 4³/₈ x 2½ x ³/₈ in. (11.11 x 6.35 x .95 cm). Purchased by Daniel C. Swan in Gallup, NM, 2009. Sam Noble Oklahoma Museum of Natural History, the University of Oklahoma, 2009.6.3.

in which women fully participate in the ceremony, leading songs and drumming alongside their male counterparts.[9] While female participation in Navajo Peyotism is far from reaching parity with males, it undeniably has the potential to significantly increase the number of neophytes attempting to obtain ritual instruments.

My research is currently focused on quantitative assessments of the various modes of market exchange that are involved in the circulation of Peyote arts in and beyond the Navajo Nation. I am particularly interested in instances of direct marketing by the individuals who create Peyote arts in the Navajo community. In this context Peyote arts represent a current set of opportunities in a longer trajectory of "selling" as a major component in Navajo entrepreneurship and the informal economy of the reservation (Francisconi 1998, 83–89).

Navajo Peyote arts provide an important opportunity to examine the intersection of kin-based and capitalist exchange networks similar to those discussed by Berman (2003, 51–54). The increasing importance of cash in ceremonial systems in the twentieth century has created additional exchange value in the production of artistic works that might otherwise assume ceremonial importance and accrue biographic

Fig. 61: Breakfast Bowl, about 1999. Etched glass, Phoenix, AZ. Purchased by Daniel C. Swan at Cool Runnings, St. Michaels, AZ, 2000. From the collection of the Gilcrease Museum, Tulsa, OK, 57.499.

This bowl is part of a set of three used to serve the ritual breakfast that concludes the religious service of Peyotism. The etched decorations indicate that this bowl is for pounded meat; the other components of the meal are fruit and parched corn.

value. Alternatively, they might be converted to cash, a long-standing aspect of Peyotism in which money is necessary to purchase commodities central to the ceremonial practice of Peyotism, including food for the feasts associated with religious services; the sacred medicine, Peyote, from registered dealers in Texas; and blankets and other goods to be given to officials and participants by the sponsors of religious services.

My collecting activities are consistent with a pattern that emphasized purchase as the means of acquisition, both directly from artists and from formal and informal commercial outlets. Individuals from James Mooney to the author have depended on purchase and commission as the primary method of acquisition of Peyote arts for museum collections (Merrill et al. 1997,10, 22; Moses 1984, 61,71–72, 98,109). While the Navajo situation is impressive in scale, it is not as unique as I once assumed. Instead it represents an additional episode in the periodicity of the commercial market for Peyote arts that is, in turn, driven by demand prompted by religious expansion and growth.

Today it would be immensely difficult, if not impossible, to assemble Oklahoma-focused collections of similar scale and quality to the Howard and Cooley collections. The lack of commercial access described by Lessard (1984) for South Dakota and Wiedman (1985) for Oklahoma remains consistent, if not more extreme, in Oklahoma in the early twenty-first century. Increasingly, Peyotists from Oklahoma, Montana, South Dakota, and other regional centers of Native American population travel to Gallup to purchase Peyote arts, and I increasingly see the works of Navajo artists in Native American Church contexts in Oklahoma. The epicenter of commercial access to Peyote arts has shifted over the past forty years from Anadarko, Oklahoma, to Gallup, New Mexico, largely due to changing demographics of new membership and patterns of

religious participation. Considerable work remains to be undertaken to fully understand the relationship between market-driven circulation and ceremonial relations of production. The movement of Peyote arts, and in particular the ritual instruments used to conduct the religious ceremony, both within and beyond native communities, provides a unique opportunity to pose a range of academic questions related to aesthetic diffusion, cultural accommodation, and museum collecting. It is important to emphasize that for practitioners of the Peyote religion, these objects are instruments of prayer, which when put into ritual action provide a route to healing and spiritual guidance. The concept of motion is central to the ethos of Peyotism and functions at multiple levels in the history and current life of the religion. The establishment of a new fireplace (congregation), the initiation of new practitioners, and the creation and exchange of Peyote arts contribute to our understanding of religion in daily life.

The history of Peyote arts epitomizes the interrelations among museums, markets, and ceremonial activity as a major manifestation of cultural vitality and resurgence as framed by James Clifford (1991). The production and circulation of Peyote arts has always been centered in native communities and among members of the Native American Church. The general creed of gift giving, underscored by the tendency for members and leaders to accumulate their ritual objects through manufacture and exchange, continues to stimulate the production of new objects and materials wherever the religion is practiced.

NOTES

I would like to express my appreciation to the Denver Art Museum for the invitation to participate in the *Art in Motion* symposium. This essay is an outgrowth of my paper presented at the symposium, and it greatly benefited from the inspiring presentations and comments of my fellow participants. I would also like to thank Jim Cooley for research assistance and Kathleen Wilson for her usual good-spirited support.

[1] For exhaustive bibliographies and detailed discussion of the history, ceremony, and material culture of the Peyote Religion, the reader is referred to La Barre 1989; Slotkin 1956; and Stewart 1990.

[2] I would suggest that in Oklahoma the inheritance or gift of full sets of Peyote instruments is not the common practice; the general preference is for new materials. Each individual is expected to put his or her "kit" together through multiple methods over a period of religious participation.

[3] Jake Tingley and other proprietors of Oklahoma Indian stores are largely unknown in both the history of the state and for their importance as suppliers to collectors and museums of Native American traditional arts. Many of these stores have undergone name changes during their history. For example, Nellie Stevens changed the name of the store from "Mohonk Lodge Indian Store" to "Nellie's Mohawk Indian Store" when she assumed ownership about 1974. The previous name reflected its origin as an industrial arts initiative of the Dutch Reformed Church through the Lake Mohonk Conference, Friends of the Indian. The first "store" was established in Colony, Oklahoma, in 1899. See Barrows 1902, 27–29. I am indebted to Jim Cooley for his generous sharing of experiences and memories from his patronage of Oklahoma Indian stores in the 1960s.

[4] Tingley Indian Store Records, 1890–1990; http://beta.worldcat.org/archivegrid/data/70979281. Accessed July 17, 2013.

[5] Harding Big Bow died in 1997 and did not live to see the exhibition come to fruition. Following a series of discussions with his family and other leaders of the Native American Church of Oklahoma, the museum decided to pursue the exhibition project in modified form and content.

[6] The acquisitions at the Gilcrease Museum were supported through the City of Tulsa Acquisitions Fund, the Thomas Gilcrease Museum Association, the Frankie Van Johnson Memorial Fund, and the Phillips Petroleum Company. Acquisitions at the Sam Noble Museum were supported through the Fred and Enid Brown Acquisitions Fund.

[7] It is important to emphasize the fact that Navajo Peyotists and artists represent an incredibly diverse set of individuals who define their Navajo identity in myriad ways. Lloyd Lee provides a critical contribution to our understanding of Navajo philosophy and worldview in his balanced assessment of the scholarship by both Navajo and non-Navajo authors (Lee 2006, 88–89, 91–92).

[8] The role of Gallup, and border towns in general, in retarding economic development on the Navajo Nation is a common topic of discourse among tribal officials and artists. My work on the production and circulation of Navajo Peyote arts includes an attempt to construct a balanced consideration of a broad range of quantitative and qualitative variables.

[9] The Peyote ceremony is largely composed of multiple rounds of individual singing and drumming in which the participants take turns singing four songs as the ritual instruments travel around the circle in a clockwise direction. In most Peyote meetings in Oklahoma, men who contribute to the singing content of the service sit in a circle closest to the fire. Women, children, and non-singing males sit in an outer circle behind them, with women singingly softly in unison when their male relatives sing. Among the Navajo it is the general practice for women to sit in the inner circle and lead songs. I have also heard that there are instances among the Navajo when women also serve as Roadmen, leading religious services and performing all of the duties and activities of their position.

REFERENCES CITED

Aberle, David. 1982. *Peyote Religion Among the Navaho.* University of Chicago Press.

Barrows, Isabel C., ed.1902. *Proceedings of the Nineteenth Annual Meeting, Lake Mohonk Conference of Friends of the Indian, 1901.* New York: Lake Mohonk Conference.

Berman, Tressa. 2003. *Circle of Goods: Women, Work, and Welfare in a Reservation Community.* Albany: State University of New York Press.

Clifford, James. 1991. "Four Northwest Coast Museums: Travel Reflections," in *Exhibiting Cultures: The Poetics and Politics of Museum Display*, edited by Ivan Karp and Steven D. Lavine, 212–54. Washington, DC: Smithsonian Institution Press.

Diné Development Corporation 2008. Navajo Nation Demographics. http://www.navajobusinessdevelopment.com/information/navajo-nation-demographics.html. Accessed August 12, 2012.

Francisconi, Michael Joseph. 1998. *Kinship, Capitalism, Change: The Informal Economy of the Navajo, 1868–1995.* New York: Garland Publishing.

Frisbie, Charlotte. 1987. *Navajo Medicine Bundles or Jish: Acquisition, Transmission, and Disposition in Past and Present.* Albuquerque: University of New Mexico Press.

Jones, Ruthe Blalock. 1995. "Like Being Home: Oklahoma Indian Art." *Gilcrease Journal* 3 (2): 6–21.

La Barre, Weston, 1989. *The Peyote Cult.* Norman: University of Oklahoma Press.

Lee, Lloyd. 2006. "Navajo Cultural Identity: What Can the Navajo Nation Bring to the American Indian Identity Discussion Table?" *Wicazo Sa Review* 21 (2): 79–103.

Lessard, Dennis. 1984. "Instruments of Prayer: The Peyote Art of the Sioux." *American Indian Art Magazine* 9 (2): 24–27.

Merrill, William L., Marian Kaulaity Hansson, Candace S. Greene, and Frederick J.Reuss. 1997. *A Guide to the Kiowa Collections at the Smithsonian Institution.* Smithsonian Contributions to Anthropology Number 40. Washington, DC: Smithsonian Institution Press.

Milsten, David. 1991. *Thomas Gilcrease: Founder of the Thomas Gilcrease Institute of American History and Art.* Tulsa: Coman and Associates.

Moore, Ellen K. 2003. *Navajo Beadwork: Architectures of Light.* Tucson: University of Arizona Press.

Moses, L. G. 1984. *The Indian Man: A Biography of James Mooney.* Urbana: University of Illinois Press.

Myers, Fred. 2001. *The Empire of Things: Regimes of Value and Material Culture.* Santa Fe: School of American Research.

Norris, Tina, Paul L. Vines, and Elizabeth M. Hoeffel. 2010. *The American Indian and Alaska Native Population: 2010.* Washington, DC: U.S. Department of Commerce.

Slotkin, J. S. 1956. *The Peyote Religion.* New York: Free Press.

Smith, Huston, and Reuben Snake, eds. 1996. *One Nation Under God: The Triumph of the Native American Church.* Santa Fe: Clear Light Publishers.

Stewart, Omer. 1990. *Peyote Religion: A History.* Norman: University of Oklahoma Press.

Swan, Daniel C. 1998. "Peyote Arts in the Collections of Gilcrease Museum." *American Indian Art Magazine* 24 (2): 36–45.

———. 1999. *Peyote Religious Art: Symbols of Faith and Belief.* Oxford: University Press of Mississippi.

———. 2003. "The Anthropology Collection," in *Treasures of Gilcrease,* by Anne Morand, Kevin Smith, Daniel C. Swan, and Sarah Erwin. Tulsa: Thomas Gilcrease Museum Association, 9–21.

———. 2008. "Contemporary Navajo Peyote Arts." *American Indian Art Magazine* 33 (4): 44–55, 94.

———. 2010. "Objects of Purpose—Objects of Prayer: Peyote Boxes of the Native American Church." *Museum Anthropology Review* 4 (2): 156–89.

Swan, Daniel C., and Harding Big Bow. 1995. "Art of the Native American Church: Symbols of Faith and Belief." *Gilcrease Journal* 3 (2): 22–43.

Wiedman, Dennis. 1985. "Staff, Fan, Rattle and Drum: Spiritual and Artistic Expressions of Oklahoma Peyotists." *American Indian Art Magazine* 10 (3): 38–45.

Dancing Figures
Lakota Traditions and Innovation

Charlene Holy Bear

Sculptural representations of animals and humans offer invaluable insight into a culture's relationship with the physical and spiritual world. Such material culture has intrigued the minds and hearts of historians and collectors from across all cultures. In the Great Plains region, these sculptural representations can help depict the evolution of the Lakota Sioux's use of technology and adaptation to the changing physical and political environments experienced with the United States' expansion into the West. Often Lakota culture is romanticized as stoic and static. However, a study of Lakota material art highlights the one facet that defines life on the Great Plains: movement. Lakota sculptural representation is art in motion.

Adaptation of any kind is the act of conceptualizing and experimenting with the information currently available; the same is true for the creation of art. This process is ongoing. It does not stop with a finished product. Lakota sculptural representation is the result of a process that involves an accumulation of time that in itself utilizes intense creativity and energy. In creating such figures, an artist draws on a lifetime of experience and exploration of materials within the confines of what was and is available to create with. During this process, an artist will evolve in her or his perspectives and interpretation of ideas and improve upon her or his artistic skills. Many artists view this act of transformation as art in itself,

as well as a conversation with the creative energy around us.

The movement from traditional art to what is considered contemporary art is itself a circular motion through time. In other words, what is traditional was actually contemporary at one time. Lakota sculptural representations were created to reinforce a stoic position. They serve to highlight an ideal portrayal of a culture's beauty and sophistication. Egyptian panels on tomb walls illustrate this point. However, there is kinetic energy inherent in all things. This leads to the question: how does a Native artist capture time and movement in a fixed form, specifically in sculpture or in mixed-media figures and dolls? In this essay I will focus on two examples of Lakota Sioux sculptures that perfectly illustrate how an artist captures and portrays the kinetic movement of horses and then discuss how I achieve this sense of movement in my own art.

Horses became an essential facet of Lakota society after they were introduced to the Plains by Spanish explorers. Prior to the use of horses, dogs played an important role that made life easier on the Great Plains. The Lakota term for horse, *Sunka Wakan*, loosely translates to "Holy (Sacred) Dog." The pipe in the form of a running horse, from the Smithsonian Institution, is a great introduction to portraying movement in Great Plains sculpture (fig. 62). Here one can see that the artist was innovative in the use

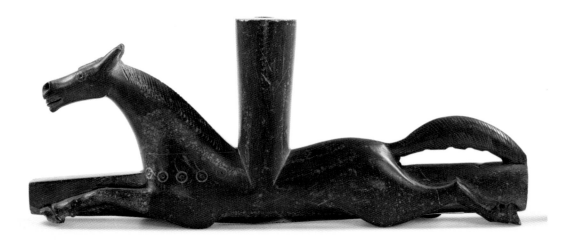

Fig. 62: Sioux artist, Running-horse effigy pipe, before 1898. Catlinite. Department of Anthropology, Smithsonian Institution, E200307.

of material and composition, with the back of the horse serving as the base for the tobacco bowl.

Another example of representational sculpture that illustrates how Lakota artists have blended art and motion is the masterful Sioux Horse Effigy dance stick from the South Dakota State Historical Society (fig. 63). The artist shows a horse leaping across an imagined field, perhaps dying from the gunshot wounds visible on its body in the form of red paint marks. This figure shows an attention to detail that only an artist intimately familiar with horses, and the role they played in Lakota life on the Great Plains, could achieve. The focus on the horse's anatomy and kinetic disposition is evidenced by the line of the neck, the length of the back, the angle of the ears, and the arrangement of the horse's legs as it leaps or stumbles from its wounds. This

sculpture is, in essence, capturing motion, and it is an art form that one could compare to both the traditional figure/doll making of previous generations and the current practice today by my sister, Rhonda Holy Bear, and me. Though typically examples of horse sculpture in Plains art are associated with the male aspect of society, there is still the female aspect to consider with regard to art in motion. Here, in the female domain, Great Plains sculpture focuses on teaching cultural traditions that transcend time. The passing on of Lakota culture through children forms the backbone of a Great Plains society. These traditions are exemplified by the use of dolls not only as playthings but also as teaching tools.

Often in the modern Native art scene, collectors prefer more "traditional" dolls because they believe this style better reflects the culture it represents.

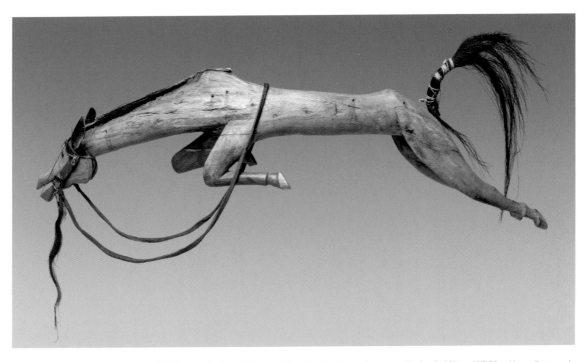

Fig. 63: Hunkpapa Lakota artist, Horse Effigy dance stick, about 1870. Wood, horse hair, leather, metal, paint, and bird quill, 38½ in. (97.79 cm) long. Courtesy of the Museum of the South Dakota State Historical Society, Pierre, SD.

However, with an understanding that culture is not static or stationary, it should be clear that the creation of figures/dolls is shaped by the introduction of outside influences. Dolls belonging to the daughters of white settlers very likely inspired Lakota mothers to create similar dolls, which resulted in a flourishing tourist trade. It should be noted that there are dolls/figures that are sacred and were created for ceremonial use. Each doll carries within itself a portion of its creator and the essence of the child it was made for. Again, a theme of motion exists within the process of creating such products of love. The dolls themselves are complete entities that not only convey a facet of

Lakota culture, but also provide a mirror into the passing of traditions from one generation to the next. It's a continuance of culture in a material form that is treasured today. It is also a record of how the members of each generation reinvent the lenses through which they see their identity within a society that was mangled not only by cultural assimilation but by the struggle to keep cultural traditions alive through the generations.

Not only is the reinventing and/or reimagining of material culture important, but also the cultural tradition of gathering and reassociating tribal bonds is essential to powwow culture. Functioning as a

separate subculture within modern Native culture, the current powwow tradition is intertribal, with its own identity, subcultures, oral history, and traditions.

In creating my dolls I strive to capture the motion of gesture. Doll making seems to follow along the circular path of contemporary-becoming-traditional and vice versa, and my observations of trends within powwow culture support this same phenomenon. I aim to discover how to create motion by shifting my focus from the technical aspects of customary Lakota craft—specifically hide preparation, the use of sinew or thread, and quillwork or beadwork—to human anatomy, form, function, proportions, and design. All of these elements, while essential to the Westernized idea of what is fine art, are also evident in early Native art. Native American artists today have access to current technologies and materials, which ironically also serve as a vehicle for continuing traditional arts. This is the basis of the dancing figures that I create. I will illustrate with three sculptures that incorporate ideas I have been thinking about over the last ten years.

In driving back from the 2006 Santa Fe Indian Market, I envisioned blending traditional doll making with the movement of contemporary powwow dancers. I also wanted to explore the history of how powwow dances evolved through generations into popular contemporary powwow categories by revisiting Lakota interpretations of art in motion. There is a blending of tribal cultures from many regions that has created its very own subculture and business.

Figures 64–66 are Jingle Dress dancers. If I were to contextualize figure 65 with a story, she is the descendant of the first Jingle Dress dancer (fig. 64). She holds a similar fan in honor of her grandmother. She is aware of her cultural values and also is a woman who aspires to find new appreciation for older, traditional concepts. Through her I explore the concepts that culture is ever changing through time, the motion of ideas being adopted, and the circular aspect of the Lakota worldview. In carrying on the Lakota tradition and aesthetics of beading everything, the beadwork designs on her moccasins, leggings, hair ties, necklace, and fan are inspired by painted parfleches (rawhide containers that function much like luggage to hold items while traveling). Early examples were incised with designs; later these designs were painted on. The doll's beadwork is inspired by the flowing lines of paint, which are also reminiscent of the movement of dance steps. In current powwow aesthetics, the brighter, flashier, and nontraditional color schemes are meant to capture the eyes of the judges and win the competition. In trying to historically match the current dancers' endeavors, I chose to use complementary hues to create a dynamic duo of colors: purple and yellow-gold. I used metallic accents to mimic the neon colors of today, which flash in the spotlights. I also wanted to convey a strong sense of cultural pride and conviction. She is basically saying, "I embody a traditional and contemporary Lakota woman, here and now."

The third doll/mixed-media figure I want to write about is the one that John Lukavic says inspired the theme of the symposium. I worked on this piece for over a year and half, and it is now in the collection of the Eiteljorg Museum in Indianapolis (fig. 66). Its title, *The Shawl*, represents the impressive artistic endeavors of a Lakota relative to elaborately embellish the outfit a dancer would wear. She is in mid-step of her twirl as she dances for the judges at a powwow. In this sculptural representation, the figure is dancing in the Fancy Shawl powwow category. This is a highly athletic, ambitious, elaborate, and colorful dance. The historical origin of the Fancy Shawl dance itself is highly debated. Oftentimes it is considered a dance that interprets

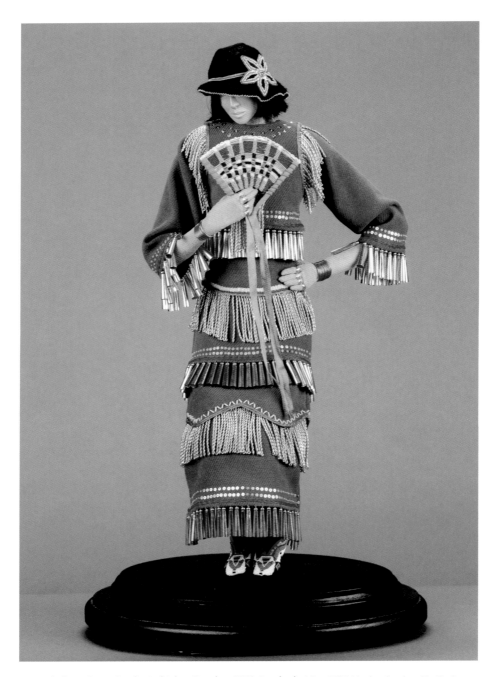

Fig. 64: Charlene Holy Bear (Standing Rock Lakota Sioux, born 1978), *Grandmother's Day*, 2007. Mixed media, about 22 x 7 x 9 in. (55.88 x 17.78 x 22.86 cm). Gilbert Waldman Collection, in memory of Nancy Waldman.

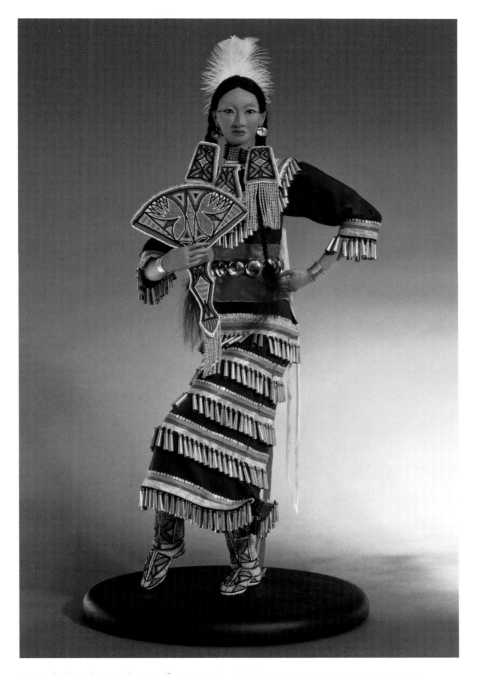

Fig. 65: Charlene Holy Bear, *Lakota Butterfly*, **2010.** Mixed media, about 22 x 7 x 9 in. (55.88 x 17.78 x 22.86 cm). Schultz collection.

the metaphor of a butterfly's transformation within the cocoon. Another story of the origin of the dance is that it evolved when brave women competed with the male dancers in the men's fancy dance. The women were so good that they kept winning over the men, and as a result they were given their own category in which to dance. Regardless of origin, I believe both stories have merit. I also took inspiration from a Lakota ceremony where a robe or shawl is given when adopting relatives or when a girl comes of age. I merged traditional motifs of the box-and-border design seen on such robes and the concepts of the butterfly and fancy dance stories and combined them in this figure. The historical interpretation of the box-and-border design is that it is a representation of the innards of the buffalo. Also incorporated into the dancer figure are the skill sets a Lakota woman is expected to have achieved upon reaching womanhood, including painting, sewing, and beading robes. Robes like this are usually elaborately painted, and a few examples, such as one in the collection of the Denver Art Museum, were actually beaded (fig. 67). In this case, I chose to do the beadwork in an effort create the rhythm of the painted lines. *The Shawl* represents a young woman who is coming of age not only through ceremony but also through the public display of a family's pride.

In this brief essay I have tried to illustrate how the artistic efforts related to Native American cultural identity form a kind of living entity that is ever-changing, ever reinventing itself, and ever-evolving as traditions pass down and environmental and cultural influences prompt adaptation and change. The powwow subculture is but one facet of this process, which I chose to explore in creating these figures. The concept of art in motion is an ongoing factor in culture and art, and my interpretations, as well as those of other artists, whether influenced by historical material culture or Pop culture, exist to convey that cultural identity is essential to keeping a culture alive.

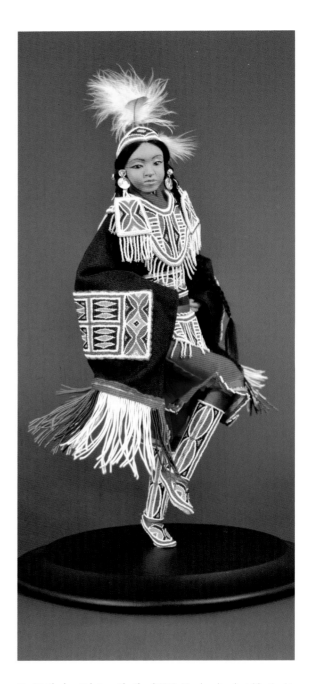

Fig. 66: Charlene Holy Bear, *The Shawl*, 2012. Mixed media, about 18 x 6 x 6 in. (45.72 x 15.24 x 15.24 cm). Eiteljorg Museum of American Indians and Western Art, Indianapolis © Charlene Holy Bear

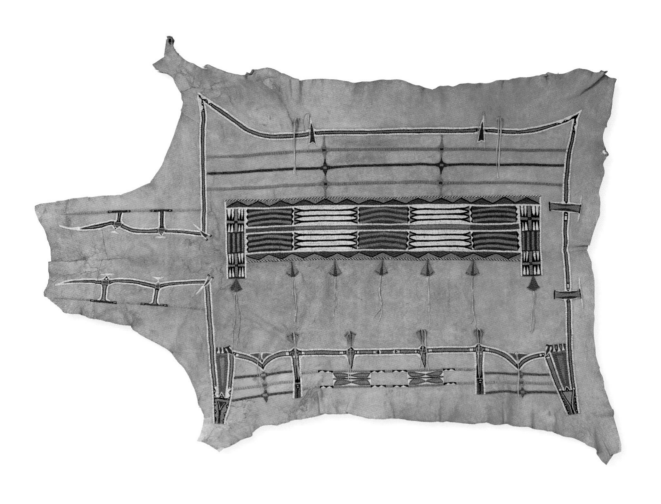

Fig. 67: Sicangu Lakota (Brule band) artist, Robe, about 1870. Bison hide and glass beads, 72 x 94½ in. (182.88 x 240.03 cm). Denver Art Museum: Native Arts acquisition fund, 1948.144.

Tlingit Ceremonialism
Changing Forms of Motion

Aldona Jonaitis

In 1805, Iurii Lisianskii, commander of the Russian naval vessel *Neva*, met with the powerful Chief Kotlean of the Sitka Tlingit. A year before, the Russians had defeated the Tlingit in a decisive battle, and they now were negotiating a peace. At one point, a group of Tlingit came to visit Lisianskii's ship, dancing several times during the meeting. After they departed, Lisianskii commented in his journal, "These people always dance and I never saw three Tlingit together without them starting a dance." A few days later, after a visit with Chief Kotlean, the commander described how the nobleman "assured us that nobody knows as many various dances as he and his subordinates. It is amazing how Sitkans are addicted to dance. To them it is one of the most important things in the world" (Dauenhauer et al. 2008, 238–40).

Tlingit dances accompanied trading activities or signified peaceful intentions. Early traders and explorers commented on the dances themselves, as well as the fine regalia and clothing, face paintings, hair strewn with eagle down, and staffs with which song leaders beat time. In 1789, the Frenchman Jean-François Galaup de la Pérouse wrote that the songs he heard in Lituya Bay were "by no means disagreeable and greatly resembling the plain chaunt of our churches." Their dances, which lasted almost an hour, were "very exact" (La Perouse, quoted in Emmons 1991, 294). That same year, Englishman

Nathaniel Portlock, visiting Sitka, was forced to wait to begin trading until he had watched a dancer first impersonate a warrior, pantomime an attack, manage the vanquished, and then transform into a woman by wearing a mask with a labret, or lip plug, which only women wore (Otto von Kotzebue, in Sitka in 1825; from Emmons 1991, 296).

Europeans often had difficulties describing the actual physical movements of Tlingit dance. Captain George Vancouver in 1793 thought they exhibited "a display of the most rude and extravagant gestures that can be imagined" (Emmons 1991, 300). G. H. von Langsdorff, in Sitka, 1805–6, tried to describe a dance that "consists chiefly in a very eager spring, in executing which the dancers scarcely remove at all from one spot" (quoted in Emmons 1991, 301). Otto von Kotzebue, visiting the same community in 1825, wrote of their "extraordinary motions with . . . arms and bodies, varying them by high leaps into the air, while showers of feathers fell from their heads" (von Kotzebue, quoted in Emmons 1991, 302). Writing in 1856, the Russian Alexandr Markov commented: "How ceremonially the savages gather on the ship on this day . . . [They] show their friendly disposition by dancing, which consists of various twisting, during the continuation of which they incessantly sprinkle themselves with eagle down" (Grinev 2005, 218).

The relationships between First Nations people and these early fur traders and explorers were by and large positive and respectful. Later in the nineteenth century, the government officials, missionaries, and settlers who arrived in Alaska judged the native people they encountered as savages, and endeavored to eradicate all aspects of Indigenous culture, such as dancing. Despite both external efforts to "civilize" the Tlingit and internal pressures to assimilate, dancing remained a central feature of Tlingit culture. Today, Tlingit dancing is still going strong, for in Juneau, every even-numbered year, the Southeast Alaska native non-profit organization, Sealaska Heritage Institute, sponsors Celebration, a song and dance extravaganza. Thousands of Tlingit and other First Nations from Alaska, British Columbia, and elsewhere march in full regalia through the city streets (fig. 68). Then, for two days, groups from different communities dance and sing from morning until night in the spacious Centennial Hall. Although outsiders are welcome as long as they pay the admission fee, the audience at Celebration is primarily native.

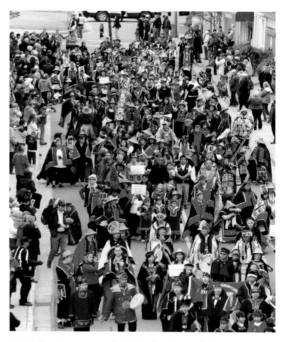

Fig. 68: Grand entrance parade, Celebration, 2012. Sealaska Heritage photo by Brian Wallace, Q8C4216.

Tlingit Culture and Dance

Like so many aspects of Native American culture, the history of Tlingit dance is a story of colonial misunderstandings, outright bigotry, traditions maintained during difficult times, and contemporary vitality that is most evident at Celebration.[1] By Tlingit dance, I mean the movements men, women, and children perform; the music that accompanies those movements; and the dazzling regalia that, by designating identity and history, suffuse these performances with profound cultural meaning.[2]

Today over 15,000 Tlingit live in Southeast Alaska. Each individual belongs to one of two halves, or moieties: the Eagles and the Ravens. Tlingit still identify themselves publicly by first naming their

mother's clan—to which, in this matrilineal culture, they belong—and then naming their father's clan from the opposite moiety. The interrelationships between the opposite yet equal Eagles and Ravens are of utmost importance; many social and cultural activities function to maintain their balance.[3] One must marry outside the moiety; not doing so is tantamount to incest. A deceased member of one moiety must be buried by members of the opposite moiety. Opposites build each other's houses, raise each other's totem poles, and host each other at lavish events called potlatches.

Along with balance is the equally central concept of ownership. Each clan owns in common tangible and intangible property; tangibles are land,

houses, and regalia, while intangibles include dances, songs, and stories. What we would call artwork—house posts, carved wooden hats, woven robes—are known as *at.óow*, treasures associated with the clan, known in English as crests.[4] Crests such as wolves, ravens, bears, and beavers appear both on portable objects such as hats, robes, and drums, and permanent artworks like carved house posts and painted interior screens. The best way to explain their significance is to quote Tlingit poet and scholar Nora Dauenhauer:

> Each [*at.óow*] records and alludes to a historical and spiritual event; each piece of visual art is associated with songs that can be heard, dances that can be seen, and spirits that are neither seen nor heard except as they are manifested in the performance at hand. [My mother said] "*At.óow* is our life.". . . Art and other *at.óow* are inseparable from life itself. . . . The *at.óow* connect the living and the dead (Dauenhauer 2000, 102).

When Tlingit present themselves in full regalia, they become reifications of their clan's entire history as well as its status, and embodiments of its past, its present, and the cultural strength of its future (fig. 69).[5]

Most dances performed for earlier travelers, like those mentioned above, signified friendliness

Fig. 69: Centennial Hall, Celebration, 2012. Sealaska Heritage photo by Brian Wallace, Q8C6564.

and readiness to trade. On occasion, a foreigner had the opportunity to see different types of dances performed within the community, such as those seen in 1827 by Captain Frederick Lutke of the Russian navy. According to Lutke, who chronicled what was in all likelihood a potlatch (*ko.éex*), the Tlingit are "great lovers of fêtes, which means for them eating without limit and dancing afterwards . . . the oldest . . . chief in the tribe treats his neighbors at his house for several days, during which they alternately eat and dance without interruption." At the end, the host chief gives his guests furs, hides, blankets, and other gifts (Emmons 1991, 302).[6]

In the 1800s, Tlingit potlatches were several-day-long events at which Ravens and Eagles both displayed their *at.óow*, songs, and dances, adhering to the principles of balance and ownership. These were occasions for the most splendid array of artworks. Dancers wore an assortment of different clothing such as Chilkat robes, painted hides, and button blankets. Headwear was very important, and included conical woven hats, wooden hats, masks, carved frontlets with sea lion whiskers, and trains of ermine pelts. Faces were painted carefully with clan designs. To accompany the songs and dances, performers shook percussive instruments such as tambourines and rattles, or men beat box drums that hung from the rafters. The setting was the clan houses where house posts and screens depicted precious crest images. This is very much still the case today during Celebration, except for dances being performed in a large communal hall (see fig. 69).

Among the Tlingit, the most significant potlatches were associated with funerary ceremonies. In the nineteenth century, when a Tlingit died, his or her moiety opposites made all the funeral arrangements. Sometime later, the family of the deceased held a *ko.éex*, the goal of which was to remember the deceased and the ancestors, conclude the mourning period, celebrate the living, reinforce social connections, display *at.óow*, and pay those of the opposite half who assisted with the funeral. Typically, hosts invited two groups of moiety opposites, one the local group who did ceremonial work, and the other from a different and sometimes distant community. When the out of town guests arrived by canoe, they danced on the beach, observed by the local guests; then the outsiders watched the locals dance (fig. 70). After these displays of songs and regalia, the hosts formally welcomed their opposites and invited their guests into the clan house. One group sat on each side of the house, facing each other, while the hosts sat at the rear.[7] Wearing their most elaborate clothing, the hosts sang, danced, made speeches, distributed food, presented valued *at.óow*, mourned the dead, and distributed to their guests material wealth such as blankets. They also "fed" the ancestors with food cast into the fire; these actions communicated the deep respect and affection the descendants felt for their predecessors. The mourning period now officially concluded, the potlatch became noticeably lighthearted, as the guests danced, sang, and presented their *at.óow*.

In the 1880s, George Thornton Emmons, a U.S. Navy lieutenant stationed in Southeast Alaska, befriended many Tlingit families and provided this vivid description of potlatch dancing:[8]

> After dressing . . . each family formed a separate procession and headed by a drum, marched to the feast house where, one at a time, they danced into the house in a stooping posture, jumping up and down in quick jerks and shaking the rattle, or moving their arms spasmodically. The dancer moved his head very slowly after entering and danced to one side of the house where all were finally assembled in many lines. The song accompanied by the drum, the rapid movement of the bodies in varied dress, the air filled with light eagle

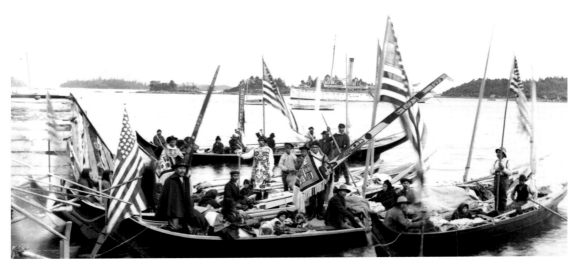

Fig. 70: Guests arriving at the Last Potlatch in Sitka, 1904. Photo by Elbridge W. Merrill, ASL-P57-019, Alaska State Library, Historical Collections.

down, the nervous expectancy of both the host and his guests that some old feud might break out through intention or want of control, all combined to make a never-to-be-forgotten scene (Emmons 1991, 312).

The "feuds" to which Emmons refers were the potential conflicts that sometimes arose between the two guest clans, each of whom wanted to outperform the other by wearing their finest clothing and regalia and executing dance steps perfectly. Each side carefully scrutinized the other's movements and songs, looking for some mistake that would demote the dancers in everyone's eyes. If one clan commented upon its rival's mistakes, or anyone voiced or even suggested insults, fighting could break out.[9]

To pacify his guests, the host would stand between the hostile parties and bring their attention to his clan's most precious *at.óow*, before which no fighting could occur (de Laguna 1972, 614–15).[10]

Clan members performed different categories of songs and dances during potlatches.[11] Some, the most valued, were prized clan possessions. Others were specifically associated with particular *at.óow*. Those families who had shamans among their ancestors sometimes presented masked dances involving shamanic spirits.[12] Dancers also imitated their crest beings, such as ravens or bears. At one potlatch, clan members whose crest was a particular glacier beat their feet rapidly on the ground, imitating the crackling sounds of the ice river's movement. In

response, a clan whose crest was a seagull acted like startled birds at this sudden sound (Dauenhauer and Dauenhauer 1990, 63). In contrast to clan possessions such as those just described, other dances were not owned by particular families. Some, for example, called "love songs," communicated positive feelings for the singers' opposites. Sorrow songs expressed mourning during memorial ceremonies. Foreign songs, learned from outsiders such as the Haida or Athabascans, were popular. And, to express gratitude during the feasting, guests would get up and dance holding their spoons.[13]

Men dance with considerable athletic prowess, move in jerky motions, crouch, and jump. More refined are women dancers who move slowly and gracefully with outstretched hands. This gender dichotomy in dancing has a parallel in Tlingit art, in which the carved and painted images of crests and other beings made by men are representational, while women's baskets and textiles with geometric patterns are non-objective.[14] The elegant, restrained, mostly rectilinear abstract art pieces that women create complement the men's dynamic, curvilinear works, just as the subtle and elegant women's dances complement the energetic movements of men's dances.[15] Although most descriptions of Tlingit dance focus on the more dramatic male performances, a complete understanding of the dance aesthetics must include the movements of both men and women.

Changes to Dance when Settlers Arrived

By the late nineteenth century, the Tlingit, who once danced in welcome and for trade with the Euroamerican visitors on sailing ships, had, for the most part, ceased performing for whites and limited dancing activities to their communities. Aurel Krause, who visited the Chilkat in 1882, commented on this, stating that such dances were rarely performed for whites, "probably because of their disregard for

them" (Krause 1956, 168). That "disregard" sometimes became outright hostility as more settlers and missionaries entered Tlingit territory. Non-natives frowned on potlatching as pagan, interpreting the act of "feeding" the ancestors—an expression of honor and respect—as committing the sin of ancestor worship. Because of occasional extravagances, potlatches gained the reputation as immense giveaways that impoverished their hosts. Although, as Sergei Kan points out, the songs and dances, the feasting, and the distribution of material goods all "express[ed] . . . key cultural values maintaining or changing the social order," missionaries in both Alaska and British Columbia completely misread the potlatch (Kan 1989, 200–201).

The Tlingit quickly learned how to survive culturally within their changing world. One way was to assure outsiders that they had abandoned potlatching when in fact they had not. In 1879, the naturalist John Muir visited Wrangell and attended a dinner hosted by the village chief and his family in honor of three important missionaries and their wives, whose goal it was to found a Presbyterian church. Muir observed "hand-clapping, head-jerking, and explosive grunt[ing] in time to grim drum-beats" by the regalia-clad dancers. After that, dancers imitated various animals, including a bear that was "so true to life in form and gestures we were all startled." The hosts then assured their guests with the following words: "this is the way we used to dance . . . When we were blind . . . But now we are not blind. We have danced today only to show you how blind we were to like to dance in this foolish way. We will not dance any more" (Muir 1979, 35).

Whereas some Tlingit did embrace Christianity and ceased potlatching activities, others, including some converts, did not stop dancing. The chiefs described by Muir appear to have understood what missionaries wanted to hear, and, good hosts that

they were, accommodated them. They may or may not have been sincere, but an effective strategy to deflect criticism from those who wanted to convert all Indigenous people and to "civilize" them was insisting they had relinquished all traditions and fully embraced white ways. "Yes, you are correct," the Tlingit would assert. "This is the very last time we are doing this, to demonstrate our past sins." And later, when left alone, some resumed their traditions.

In 1885, the Canadian government outlawed the potlatch as part of its general policy to eradicate native culture. This anti-potlatch law was enforced sporadically until 1921, when British Columbia Indian agent William Halliday arrested a group of Kwakwaka'wakw who had participated in a major potlatch. He gave them the option: relinquish your regalia or go to jail. While many gave him valuable regalia, masks, and ceremonial objects, several who would not give up their treasures went to jail.[16]

John Brady, who served as governor of the District of Alaska from 1897 to 1906, judged such criminalizing of cultural practices misguided. Brady had started out as a Presbyterian missionary among the Tlingit and Haida and, although like his colleagues his goal was to transform the native people into "civilized" members of society, he did have a deep sympathy and respect for the cultural and artistic traditions of Southeast Alaska natives.[17] Instead of threatening imprisonment, Brady would convince the Tlingit to give up potlatching by promoting one last, great event, which came to be known as the "Last Potlatch," held at Sitka in 1904. Brady understood the importance of balance within Tlingit culture. In his view, at that event, all existing inter-moiety obligations and ceremonial debts would be settled, and thus a final balance would be achieved. Afterwards the "civilized" Tlingit, released from their allegiance to the clan, would no longer have any reason to potlatch. In a letter he wrote to Secretary of the Interior Ethan Allen Hitchcock soliciting funds for this event, Brady asserted that it "would result in a lasting good to the people themselves and would save the United States many thousands of dollars in the way of criminal prosecution" (Preucel and Williams 2005, 12).

In late December 1904, several Sitka Eagle moiety chiefs hosted a lavish, four-day-long affair of feasting, dancing, and distribution of wealth for Raven moiety clans from Angoon, Hoonah, and Klukwan (fig. 71).[18] Some participants acquiesced in the finality of this event, including one clan that relinquished a prized possession—the Raven hat that had been worn in the 1804 battle against the Russians. According to the clan speaker, this act represented that "we have given up the old customs" (Hinckley 1996, 338).[19] But for others, this was absolutely *not* the final, dying breath of a disappearing ceremony. In fact, according to the local newspaper, "the old Indians who never took kindly to the white man's religion are happy, and they are using the opportunity to impress upon the younger members of the tribe what they regard as the necessity of maintaining their old customs and traditions" (Preucel and Williams 2005, 14). And so, the twentieth century began with this ironic reinforcement of the Tlingit potlatch.

Dance in the Twentieth Century

Like so many other native traditions, Tlingit potlatches changed with the times rather than being eradicated. They became shorter, lasting only a day or two. New experiences motivated the creation of new outfits and original dances. For example, after a Japanese vessel visited Southeast Alaska, participants at one potlatch wore kimonos and Japanese-style haircuts.[20] Potlatch-like events occurred during the Christmas season when gift-giving was acceptable to whites. One Christmas party in Klukwan was festively interrupted by a group of Tlingit men wearing

Fig. 71: Klukwan (Chilkat) Tlingit in dancing regalia at the Last Potlatch, Sitka, 1904. Photo by William R. Norton, ASL-P226-368, Alaska State Library, Historical Collections.

deer skins and antlers, impersonating Santa Claus and his reindeer (Hinckley 1996, 374). In 1921, amateur photographer Seiki Kayamori, who lived in Yakutat, photographed dancers wearing traditional clothing performing within a house (Thomas 2015,106; Gmelch 2008,169) (fig. 72).

In 1940, another "last potlatch" took place in Wrangell at the investiture of a new Chief Shakes and dedication of the renovated Chief Shakes House, which was done as part of the Indian Division of the Civilian Conservation Corps projects. According to the local newspaper, the *Wrangell Sentinel* (June 7, 1940), over 1,500 people attended this lavish affair, where dancers from Wrangell, Kake, Angoon, and Klawock performed. Demonstrating the significant change in governmental attitude toward native culture, the Alaska Territorial governor, Ernest Gruening, spoke positively about the event,

recognizing that native traditions could be appealing to outsiders. He specifically compared this demonstration of Tlingit songs and dances with Hawaiian native performances, which tourists travel thousands of miles to see.

Some "progressive" Tlingit insisted that social equality and economic advancement could be achieved only by assimilating and appropriating white ways. From the time settlers began arriving in Alaska in the 1880s, native rights had been abrogated. Non-natives appropriated land with no regard to its traditional owners. They denied Tlingit access to clan-owned fishing streams and rivers. Signs outside stores stating "No dogs or Indians allowed" and sections of movie theaters specified as "whites only" were indications of Alaska's policy of legal segregation. In 1912, a group of Christian Tlingit men assembled in Sitka to found the Alaska Native

Fig. 72: Dance at Billy Jackson's house, Yakutat, about 1921.
Photo by Seiki Kayamori, ASL-P55-348, Alaska State Library, Historical Collections.

Brotherhood (ANB), the objective of which was to "afford mutual help, to encourage education among the Indians, and to secure . . . more of the benefits of civilization" (Dauenhauer and Dauenhauer 1994, 84). Three years later the Alaska Native Sisterhood (ANS) was founded on similar principles. In order to accelerate assimilation, ANB meetings were held in English, and anyone speaking Tlingit was fined. Within a few decades, the ANB had achieved several notable victories for Alaskan natives: the right to vote; the right of workers' compensation; and the right of native children to attend public schools.[21]

ANB officially rejected potlatching as an obstacle to advancement. But in reality, many ANB practices corresponded quite closely to those of the potlatch. Formal terms for addressing one's opposites were standard, as was the calling on them to perform various duties. These duties required remuneration by gifts that, instead of going to clans, went to the ANB treasury. Members would make contributions to the ANB in memory of deceased relatives. And, sometimes individuals would even intentionally bring out treasured *at.óow*, then pay a fine. As Philip Drucker states in his study of native brotherhoods, "such performances are obviously the essence of the potlatch, that is, the potlatch stripped of its ritual, and with the ANB replacing the clans of the opposite moiety as recipient" (Drucker 1958, 60).

Dance was officially frowned upon by the organization.[22] However, in the 1930s and 1940s, some ANB camps needed funds to support their land claims and other legal initiatives; to raise money, they sponsored traditional dance performances for which they charged admission (fig. 73). While the purpose was to raise money, older participants insisted on accurate dance steps, appropriate regalia, and exact songs. As time went on, few of those who had freely potlatched in the nineteenth century remained to educate the young on these traditions. To ensure

Fig. 73: Benefit dinner at ANB Hall, Hoonah, 1940–44. ASL-P01-2250, Alaska State Library, Historical Collections.

authenticity, in the 1950s and 1960s dance groups taught by knowledgeable elders were formed in several communities. As a result, younger men and women had the opportunity to learn their cultural traditions from elders in a more open and "acceptable" environment (Kan 1999,506) (fig. 74).[23]

The original dance groups consisted of clan siblings, which made sense since important songs and dances were clan owned. But this changed as well. Jennie Marks of Juneau had considerable knowledge of songs and dances, both from her own clan and that of her husband. In the 1960s, when she was in her seventies, she started teaching both Raven and Eagle traditions to relatives and friends, initiating the group called the Marks Trail Dancers. This was the first modern Tlingit dance group that contained members of different clans, all of whom sang clan songs, something that would have been horrifying to everyone from earlier generations, as well as to some more-conservative Tlingit of the time (Dauenhauer and Dauenhauer 1994, 427).[24] Today many dance groups are community-based with

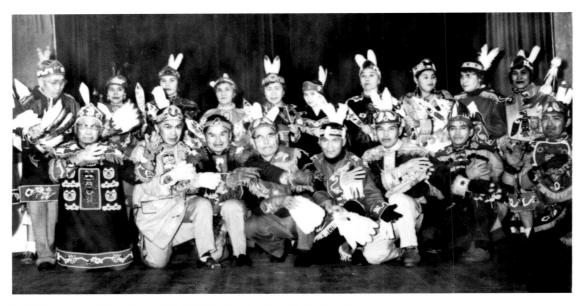

Fig. 74: Group portrait of Yakutat dancers, 1959. ASL-P33-33, Alaska State Library, Historical Collections.

members from different clans and opposite moieties. Such organization by geography rather than descent parallels the current political and economic organization of the Tlingit. In Alaska in 1971, land claims were settled by the passage of the Alaska Native Claims Settlement Act (ANCSA), in which land allotments and payments for land were distributed among newly formed for-profit regional corporations—such as Sealaska Corporation—as well as villages. As Tlingit anthropologist Rosita Worl points out, all clans participate in the ANB and ANS, in the regional and village corporations formed by ANSCA, and in the Tlingit and Haida Central Council, an organization founded in 1935 to pursue land claims (Worl et al. 2008, 93). It is thus not surprising that cultural organizations such as dance groups are similarly catholic.

By the 1980s, even conservative ANB and ANS members publicly acknowledged the value of maintaining Tlingit cultural traditions. In May 1980, the Sealaska Corporation sponsored a meeting, "Sealaska Elders Speak to the Future," which addressed the need for slowing down ongoing cultural losses. In response, Sealaska Corporation formed the non-profit Sealaska Heritage Foundation (now called Sealaska Heritage Institute, SHI), dedicated to preserving native language, art, and culture in Southeast Alaska. Two years later, SHI inaugurated Celebration, a new kind of public dance event intended to educate the younger generation. The first Celebration, in 1982, involved around 200 people, mostly adults, who considered it a great success (fig. 75). In the years that followed, more dance groups were founded, more regalia were made,

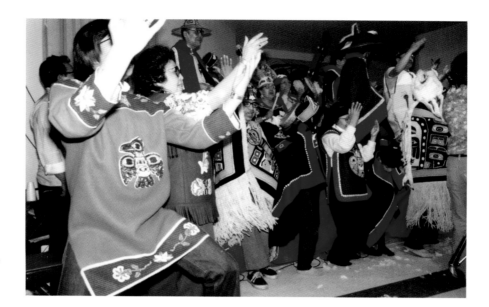

Fig. 75: Dancers at first
Celebration, 1982 (Johnny
Marks in center with
Chilkat robe). Photo by Larry
McNeil. Sealaska Heritage
Dauenhauer Photograph
Collection, 2:112.

and more young people learned ancient songs and dances and invented new ones. Today the biannual Celebration has grown to over 2,000 participants, with forty to fifty dance groups and thousands of spectators (fig. 76).

In the past, Tlingit ceremonialism, based on the concepts of balance and ownership, declared through song, dance, oration, and display of *at.óow* the past, present, and future of a clan and its relationship with clans of the opposite moiety. Today, even in dance groups composed of members from different clans, individuals will display their own family's heirlooms and crest emblems and formally acknowledge song and dance ownership. Thus, the historical meanings and functions of Tlingit ceremonialism remain central to Celebration, even if individuals from different moieties dance together.

In addition to maintaining cherished traditions, Celebration embodies a more contemporary message of cultural survival and pride. David Katzeek, the first president of Sealaska Heritage Institute, comments:

> The greatest contribution of Celebration is the recognition, acknowledgment and acceptance of ourselves and not being afraid to let people know who we are. We want our voice to sound across the land, and that's what happens at Celebration. Thousands come. And our voices ring across the land (quoted in Worl et al. 2008, 18).

It is not infrequent that native art expresses "double messages," with one message directed toward the outside world and the other to the native group (Berlo and Phillips 1998, 213–15).

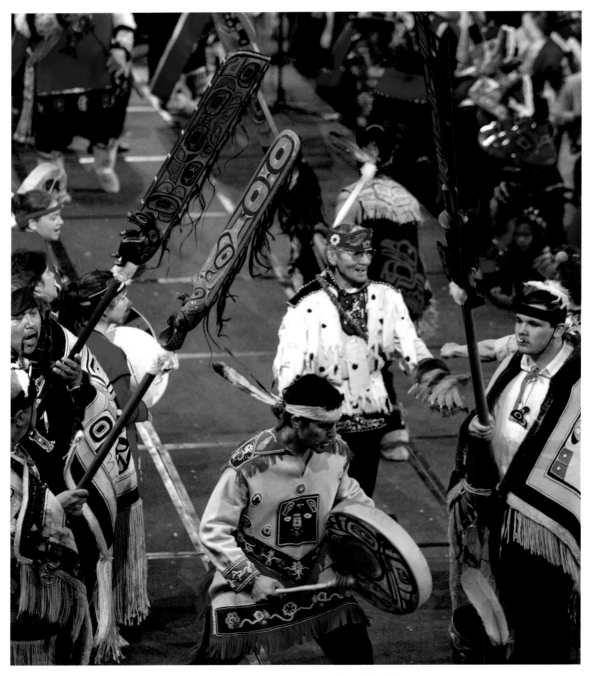

Fig. 76: Dancers wearing regalia during Celebration, 2012. Sealaska Heritage photo by Brian Wallace, Q8C4779.

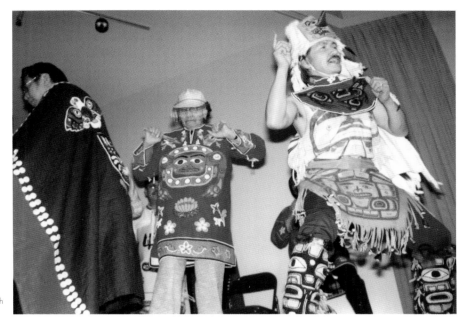

Fig. 77: Nathan Jackson and Celia Kunz dancing at the first Celebration, 1982. Photo by Larry McNeil. Sealaska Heritage Dauenhauer Photograph Collection, 1:86.

Similarly, Celebration can be understood as both endorsing the social values of the past and displaying Indigenous identity to those non-natives who for so long dismissed Tlingit culture. Nathan Jackson, the preeminent Tlingit carver, is also a well-known and talented dancer (figs. 77–78). He learned this art in Haines, Alaska, when as a teenager he watched the elders dance.[25] He listened to songs, took in the beat, looked at people who were good dancers, imagined what they were like when young, imitated their movements, and thus learned to dance.[26] Gradually dance became the foundation of Jackson's identity. As a member of the Raven moiety, he performed raven movements; when dancing, "getting low to the ground, wearing a Chilkat blanket, I feel energized." Jackson envisions his young grandson dancing in the future; since the child lives in New York City, Jackson plans to send him a video of dances so he can familiarize himself with the music and steps (Jackson, interview, June 11, 2012). So the past still exists and the future is assured.

NOTES

[1] This has been the theme of my recent publications on Northwest Coast art; see Jonaitis 2006, 2012; and Jonaitis and Glass 2010.

[2] Mique'l Dangeli's Ph.D. dissertation (2015) addresses a specific and important feature of Northwest Coast dance, how modern First Nations dance artists enact what she terms "dancing sovereignty."

[3] In the words of two of the major interpreters of Tlingit culture, Nora Dauenhauer and Richard Dauenhauer, the "two main features [that] characterize Tlingit culture and oral tradition [are] ownership and reciprocity (popularly called 'balance')" (Dauenhauer and Dauenhauer 1994, 13).

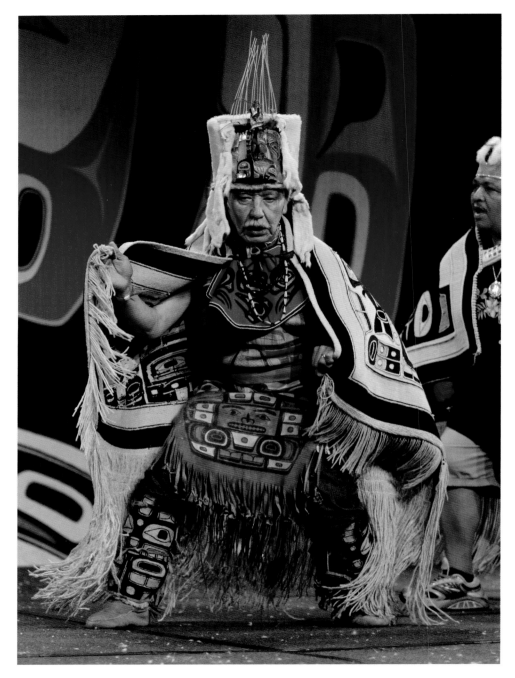

Fig. 78: Nathan Jackson at Celebration, 2012. Sealaska Heritage photo by Brian Wallace, Q8C1429.

[4] *At.óow* also can be specific places that played roles in a clan's history. See Thornton 2008.

[5] In the early nineteenth century, the presentation of *at.óow* was usually restricted to potlatches; one exception, according to the Russian priest Ivan Veniaminoff, later canonized as St. Innocent of Alaska, who wrote of the Tlingit in the late 1830s, stated that "the Sitka Tlingits have a chance to put these outfits on even without a big party, namely when they dance on the ships which come from Russia" (Veniaminoff 1982, 22).

[6] Northwest Coast people from the Puget Sound Salish up north to the Tlingit have specific variations on the potlatch, which always consists of a host family inviting guests not of its lineage; presenting its dances, songs, objects and stories; feasting its guests; and distributing gifts as payments for their services as validators of the displayed tangible and intangible property.

[7] De Laguna 1972, 610 ff. provides a greatly detailed account of the potlatch that includes the number of days each component took in the past. Today these elements are compressed. See also White and White 2000 for an excellent summary of events at the *ko.éex*.

[8] Emmons also removed huge numbers of sacred objects from shamans' graves and sold them to museums.

[9] For more on this rivalry, see Kan 1989, 224–31.

[10] The Tlingit also had a Peace Ceremony that signaled the end to warfare; this event included dance and song. See Austin 2000.

[11] Guests designated song leaders who would keep the rhythm by carrying dance paddles (de Laguna 1972, 618–19). Two men on the arriving canoe in figure 70 carry such paddles.

[12] According to Frederica de Laguna (1972, 632), such spirit songs became more common at potlatches as shamans became less important, and their songs were considered clan property that could be presented at potlatches. See also Kan 1989, 229–31.

[13] For more details on the songs and dances see Dauenhauer and Dauenhauer 1990, 57–65.

[14] For Chilkat robes, which depict crests, women copy pattern boards painted by men.

[15] This is of course not limited to the Tlingit; in many cultures men and women dance differently.

[16] This, perhaps the most well-known historic potlatch, has been extensively written about; see Cole and Chaikin 1985.

[17] One of Brady's major accomplishments was convincing Tlingit and Haida chiefs to donate their totem poles to a new park he envisioned for Sitka. These poles became the first that stood in the Sitka National Historic Park, visited today by thousands of tourists; see Jonaitis and Glass 2010. While some whites condemned Brady as being too pro-Indian, Brady has his native detractors as well; see Dauenhauer and Dauenhauer 1990, 136 for criticisms of his treatment of Tlingit land issues.

[18] Photographs of this event have been repeatedly published; one appears on the cover of Emmons 1991. For more on the photographs, see Gmelch 2008, 179–83.

[19] The hat is now in the Sheldon Jackson Museum in Sitka.

[20] Changes were becoming apparent earlier as well; in 1881, Aurel Krause spent time among the Chilkat Tlingit and described a New Year's performance in the schoolhouse in which native dances and masquerades were performed, and then dancers in blackface mimicked white people's dances. Krause explains that dancers had black faces "perhaps out of consideration of the presence of white people" (Krause and Krause 1993, 125).

[21] For more on the ANB, see Dauenhauer and Dauenhauer 1990, 28–32; Dauenhauer and Dauenhauer 1994, 83–96; and Drucker 1958.

[22] But non-native music was not. In the early 1900s, until about World War II, musicians in communities like Hoonah, Angoon, and Sitka formed brass bands, which played non-native music (Dauenhauer and Dauenhauer 1994, 375–77, 459). See Gmelch (2008, 80) for a photograph of the Juneau Native Band in 1905.

[23] In 1952, the Klukwan dancers performed at the ANB/ANS meeting; Carl Heinmuller, a white man sympathetic to natives, saw them and thought it would be wonderful if his Boy Scout troop, which included both natives and non-natives, could attend the 1957 Boy Scout jamboree in Pennsylvania and perform Chilkat dances. The elders refused him, as he was not a member of the tribe, but he finally convinced David and Margaret Katzeek to teach the boys. Thus began his dance troupe, the Chilkat Dancers.

[24] This remained an issue for many years, with traditionalists maintaining the inappropriateness of non-clan members singing clan songs. Ultimately, the general consensus arose that young people learning traditions was an important goal, and if it meant bending past rules, so be it. Today, all songs are introduced by acknowledging their owners. See Ostrowitz 2009, 90–94.

[25] Some of these were Jack David, Victor Hotch, and Glen Katzeek.

[26] After he returned from the army, Polly Sargent from Hazelton asked him to teach dancing at 'Ksan, which he did, working with the older people, drawing them out, and teaching Tsimshian dances.

REFERENCES CITED

Austin, Kenneth Frank. 2000. "The Northern North Pacific Peace Ceremony," in *Celebration 2000: Restoring Balance through Culture*, edited by Susan Fair and Rosita Worl. Juneau: Sealaska Heritage Foundation, 155–58.

Berlo, Janet, and Ruth Phillips. 1998. *Native North American Art*. New York: Oxford University Press.

Cole, Douglas, and Ira Chaikin. 1985. *An Iron Hand upon the People: The Law against the Potlatch on the Northwest Coast*. Seattle: University of Washington Press.

Dangeli, Mique'l. 2015. *Dancing Sovereignty: Politics and Protocols of Northwest Coast First Nations Dance*. Ph.D. dissertation, University of British Columbia Department of Art History.

Dauenhauer, Nora Marks. 2000. "Tlingit *At.óow*," in *Celebration 2000*, edited by Susan Fair and Rosita Worl. Juneau: Sealaska Heritage Foundation, 101–6.

Dauenhauer, Nora Marks, and Richard Dauenhauer, eds. 1990. *Háa Tuwunaagu Yís, for Healing Our Spirit: Tlingit Oratory*. Seattle: University of Washington Press, and Juneau, with Sealaska Heritage Foundation.

———. 1994. *Haa Kusteeyí, Our Culture: Tlingit Life Stories*. Seattle: University of Washington Press, and Juneau, with Sealaska Heritage Foundation.

Dauenhauer, Nora Marks, Richard Dauenhauer, and Lydia T. Black, eds. 2008. *Anóoski Lingít Aaní Ká/Russians in Tlingit America: The Battles of Sitka, 1802 and 1804*. Seattle: University of Washington Press, and Juneau, Sealaska Heritage Institute.

de Laguna, Frederica. 1972. *Under Mount St. Elias: The History and Culture of the Yakutat Tlingit*. Washington, DC: Smithsonian Institution Press.

Drucker, Philip. 1958. "The Native Brotherhoods: Modern Intertribal Organizations on the Northwest Coast." *Smithsonian Institution, Bureau of American Ethnology Bulletin* 168. Washington DC: U.S. Government Printing Office.

Emmons, George Thornton. 1991. *The Tlingit Indians*. Edited and with additions by Frederica de Laguna. New York: American Museum of Natural History.

Gmelch, Sharon Bohn. 2008. *The Tlingit Encounter with Photography*. Philadelphia: University of Pennsylvania Museum of Archaeology and Anthropology.

Grinev, Andrei Val'terovich. 2005. *The Tlingit Indians in Russian America, 1741–1867*. Translated from the 1991 Russian original by Richard L. Bland and Katerina G. Solovjova. Lincoln: University of Nebraska Press.

Hinckley, Ted C. 1996. *The Canoe Rocks: Alaska's Tlingit and the Euroamerican Frontier, 1800–1912*. Lanham, MD: University Press of America.

Jonaitis, Aldona. 2006. *Art of the Northwest Coast*. Seattle: University of Washington Press.

———. 2012. *Discovering Totem Poles: A Traveler's Guide*. Seattle: University of Washington Press.

Jonaitis, Aldona, and Aaron Glass. 2010. *The Totem Pole: An Intercultural History*. Seattle: University of Washington Press.

Kan, Sergei. 1989. *Symbolic Immortality: The Tlingit Potlatch of the Nineteenth Century*. Washington, DC: Smithsonian Institution Press.

———. 1999. *Memory Eternal: Tlingit Culture and Russian Orthodox Christianity through Two Centuries*. Seattle: University of Washington Press.

Krause, Aurel. 1956. *The Tlingit Indians: Results of a Trip to the Northwest Coat of America and the Bering Straits* (originally published 1885). Translated from German by Erna Gunther. Seattle: University of Washington Press.

Krause, Aurel, and Arthur Krause.1993. *To the Chukchi Peninsula and to the Tlingit Indians 1881/1882: Journals and Letters of Aurel and Arthur Krause*. Fairbanks: University of Alaska Press.

Muir, John. 1979. *Travels in Alaska* (originally published 1915). Boston: Houghton Mifflin Company.

Ostrowitz, Judith. 2009. *Interventions: Native American Art for Far-flung Territories*. Seattle: University of Washington Press.

Preucel, Robert W., and Lucy F. Williams. 2005. "The Centennial Potlatch." *Expedition* 47, no. 2: 9–19.

Thomas, Margaret. 2015. *Picture Man: The Legacy of Southeast Alaska Photographer Shoki Kayamori*. Fairbanks: University of Alaska Press.

Thornton, Thomas F. 2008. *Being and Place Among the Tlingit*. Seattle: University of Washington Press, and Juneau: Sealaska Heritage Institute.

Veniaminoff, Ivan [St. Innocent of Alaska]. 1982. "Notes on Tlingits," in *Raven's Bones*, ed. Andrew Hope III. Sitka: Sitka Community Association, 16–34. Originally published in Russian in 1840.

White, Lily, and Paul White. 2000. "*Koo'eex'*: The Tlingit Memorial Party," in *Celebration 2000: Restoring Balance through Culture*, edited by Susan Fair and Rosita Worl. Juneau: Sealaska Heritage Foundation, 133–36.

Worl, Rosita, et al. 2008. *Celebration: Tlingit, Haida, Tsimshian Dancing on the Land*. Seattle: University of Washington Press, and Juneau, Sealaska Heritage Institute.